miró

twentieth-century masters

miró

Mario Bucci

Hamlyn
London Sydney Toronto New York

twentieth-century masters
General editors: H. L. Jaffé and A. Busignani

© Copyright in the text Sadea/Sansoni Florence 1968
© Copyright in the illustrations ADAGP Paris 1968
© Copyright this edition The Hamlyn Publishing Group Limited 1970
London · Sydney · Toronto · New York
Hamlyn House, Feltham, Middlesex, England

ISBN 0 600 35924 7

Colour lithography: Zincotipia Moderna, Florence
Printing and binding: Cox and Wyman Limited
London, Fakenham and Reading

Distributed in the United States of America by Crown Publishers Inc.

contents

List of illustrations 6

The recluse in Paris 7

Childhood days and childhood things 8

The Academia de la Lonja 10

A ring of eyes round the head 11

A feeling for colour 12

An ancient heritage 13

A geometrical record 19

Dialogues with himself 22

The nature of things 25

The Farmhouse painting 26

The power of the imagination 30

Harlequin's Carnival 31

Surrealism: the subconscious and the real 33

The paintings of dreams 36

The Dutch Interiors 38

A spot falling in the right place 40

The Monster Period 41

Ladder of Escape 43

The Walls of the Sun and of the Moon 46

Colour plates 47

Description of colour plates 91

Biographical outline 92

Miró's signatures 94

Books and writings illustrated by Miró 95

Exhibitions and catalogues 95

Bibliography 96

List of colour illustrations

1. *The Peasant*, 1912
2. *Coffee-pot*, 1915
3. *Village of Montroig*, 1916
4. *The Blue Bottle*, 1916
5. *The Path, Ciurana*, 1917
6. *Nude with Bare Feet*, 1918
7. *Motherhood*, 1924
8-9. *Harlequin's Carnival*, 1924–5
10. *Figure*, 1925
11. *Painting*, 1925
12. *Painting*, 1925
13. *Dog barking at the Moon*, 1926
14. *Dutch Interior*, 1928
15. *The Baker's Wife* (after Raphael), 1929
16. *Painting*, 1930
17. Painting-collage on sand-covered cardboard
18. Painting on fibreboard, 1936
19. Painting on fibreboard, 1936
20. *Portrait III*, 1938
21. *Seated Woman*, 1938
22. *Woman in the Night*, 1945
23. *Bull-fight*, 1945
24. *Up-turned figures*, 9th May, 1949
25. *Women facing the Sun*, 1949
26. *Woman*, 1959
27-8. *Painting*, 1953
29. *Red disc in pursuit of a Lark*, 1953
30. *Woman trying to attain the impossible*, 12th January, 1954
31-2. *The Wall of the Moon*, 1957
33-4. *Blue II*, 4th March, 1961
35. *Woman and Bird, II/IX* 1960
36. *Woman and Bird*, 6th April, 1963
37-8. *The Skiing Lesson*, 1966
39. *Land of the Great Fire*
40. *Pumpkin*
41. *Land of the Great Fire*, 1955

List of black-and-white illustrations

1. *Cornudella*, 1906 — page 10
2. *Figures*, 1915 — 11
3. *Study of threshing*, 1918 — 13
4. *Village and Street, Ciurana*, 1917 — 15
5. *The Bridge, Montroig*, 1917 — 16
6. *The River, Montroig*, 1917 — 16
7. *The Harbour, Cambrils*, 1917 — 17
8. *Portrait of E. C. Ricart*, 1917 — 18
9. *Portrait of Juanita Obrador*, 1917 — 19
10. *House with Palm*, 1918 — 20
11. *Vines and Olive-trees at Montroig*, 1919 — 20
12. *Nude with Mirror*, 1919 — 21
13. *Self-portrait*, 1919 — 23
14. *Still-life with Rabbit*, 1920 — 24
15. *Portrait of a Spanish Dancer*, 1921 — 25
16. *Spanish Dancer*, 1921 — 25
17. *Farmhouse*, 1921–2 — 27
18. *The Farmer's Wife*, 1922–3 — 28
19. *Ploughed Earth, Montroig*, 1923–4 — 29
20. *Catalonian Landscape*, 1923–4 — 30
21. *Portrait of Madame K.*, 1924 — 32
22. *Hand catching a bird*, 1926 — 34
23. *Birth of the World*, 1925 — 35
24. *Portrait*, 1927 — 37
25. *Snail, Woman, Flower, Star*, 1934 — 39
26. *Man and Woman in front of a Pile of Excrement*, 1936 — 40
27. *Self-portrait*, 1937–8 — 41
28. *Woman bathing*, 1938 — 42
29. *Ladder of Escape*, 1939 — 43
30. *People in the night guided by the phosphorescent trails of snails*, 1940 — 44
31. *Engraving*, 1952–3 — 45
32. Miró with his parents and sister about 1900 — 92
33. Miró in Paris in 1927 with Arp, Mesens and Goemans — 92
34. Miró about 1930 — 93
35. A recent photograph of Miró at work — 93
36. Miró's signatures — 94

The recluse in Paris

'*A–I am 26.*

B–I have about 25 or 30 pesetas left out of the small amount I earnt as a clerk and put into the savings bank. I used it to buy paints and pay the rent of the studio. In the end, seeing my meagre resources disappear, I plucked up courage and very reluctantly asked my mother for a little money.

C–Anyway, like this, I know for sure that if I leave home and go to Paris I can count on a small sum to live on and go on working for a while.

D–If I stay in Barcelona, I can see no way out of having to do some idiotic task so as to be able to earn my keep and go on painting.

E– There is no getting away from the fact that since I have no money, I shall have to earn my living, whether I am in Paris, Tokyo or India.

But we will talk about the whole matter another time. Since you are accusing me of being obstinate, we shall see whether you can suggest another solution.'

It was the end of the winter of 1919 and in a letter to his friend, the painter Ricart, Miró was weighing up his position. Shortly before in another letter, to his friend, Rafols, he had said, 'I must go to Paris, not as a spectator at a contest, but as a contestant . . .' In another outburst, again addressed to Ricart, he wrote in bigger and bigger capitals, 'PARIS, PARIS, PARIS'. He eventually got there on 3rd March of that same year, determined to take the city by storm, and above all, to do something new, lay new foundations and free himself of the timeless quality of life in provincial Catalonia where he had been in danger of feeding on his first successes in Barcelona, which were of a purely regional and national character. He arrived with his teeth gritted, knowing that he had made a break, severed relations with his family and was heading towards new ground and towards the supreme experience which only Paris could offer. But it was to be a painful step and one whose trials, especially at the outset, he found hard to bear.

When he found himself in the squalid room in the Hôtel de Rouen, in the rue Notre Dame des Victoires, talking to his compatriot, Artigas, the only friend on whom he could count and by whom he was to some extent understood, he must have felt defenceless and alone, as if, in Paris, he was adrift on some great tide. Indeed, the city surged, stirred as much by its splendour as by its wretchedness, both as great as the size and importance of the capital. Paris, constantly yearned for and dreamed of while it continued its relentless round, had for more than half a century been the foothold and oasis of all the *avant-garde* artists of Europe and from across the Atlantic. Now, for two or three decades, it had pulsated with a new rhythm, a real modernity in which only a young man in search of a language and a means of self-expression could participate.

But when he arrived in that sad room at the outset of so many trials, the proximity of some bohemians from Barcelona living in rooms adjoining his boarding-house and scattered throughout the area, did nothing to alleviate the strangeness of those first days. Carefree and irresponsible, they sought only superficial pleasure and novelty, dining, laughing and philandering in the studios of Montmartre. Miró was in Paris to fight his own silent and determined battle, sustained by his stubborn Catalan peasant character. He had come not only to express new ideas in his painting but also to campaign against a corrupt society which pretended to be the champion of culture and idealism when in fact it was making a mockery of values and completely negating established truths on which the very concept of man and his existence are built.

Paris, like Europe and the civilised world, was just beginning to awake from the nightmare of war, but the growing spirit of revolution had not yet taken hold. A sort of unformed and confused dissatisfaction was brewing and rising menacingly. The tradition of great French painting had been broken; Courbets, Manets, Monets, and even Cézannes were already museum pieces. The world was beginning to hurtle recklessly forward, wanting to live, as the Futurists in Italy called it, 'dangerously'. Miró wrote from the city of his dreams: 'The Impressionists' storm of colour and light, captured by Cézanne – though only, it seems, for museum walls – is now over.' The Dadaist revolution had already exploded on the scene and was invading poetry and literature, as well as art. On the one hand, Breton, Aragon, Soupault, Apollinaire and Reverdy, and on the other Tristan Tzara and Bresson were the standard-bearers, very much to the fore, and preaching the good news with howls and polemical grimaces. Miró echoed this cry of revolt, which, after all, was his as well, and though he did not play an active part in the Dadaist conflict, he helped in his own particular way as a sort of soldier-priest, for like a good Spaniard he could live and let live.

Shortly after arriving and scarcely over the initial moment of shock and emptiness, he wrote to his friend Ricart, 'If you are thinking of coming to Paris just as a spectator, to see and to study the Impressionist masters and the moderns, don't hurry. As your friend, I would advise you to stay in the country until the world has calmed down a little – and then come when all is quiet. But if you want to come to Paris to fight, it would be a great mistake to let time slip idly by and think that things will be better tomorrow. I don't care a damn about tomorrow – today is what interests me. In other words, and I say this in all sincerity, I would a million times rather be a complete and utter failure in Paris than merely bob about on the putrid waters of Barcelona.' In these words is contained the real Miró and particularly the Miró of 1919, with all his lucid awareness of the front-line battle that he, the recruit trying for his stripes, was fighting.

Behind that 'stay in the country' and 'the putrid waters of Barcelona', there is clearly the memory of his early days in the cocoon of the provinces, from where he watched his chance to break out and catapult himself into the world, like one of the toy devils of his paintings. Behind that 'utter failure in Paris' lies the violent anguish and confusion that Paris engendered in him at first contact, as if an infernal giants' saraband was stunning and deafening him in his room in the little hotel. To 'stay in the country' has, in fact, always remained his wish, representing for him the most real environment, the element most essential to his personal poetry, the ideal atmosphere for his most secret and sincere emotions, and the refuge for his earliest introspections, providing calm and serenity after the first battles of his adolescence.

Childhood days and childhood things

He was born on 20th April, 1893, in Barcelona, and went to school there. He took a standard course in drawing under Sr Civil and lived for many years with his family at 4, Pasaje del Credito, a few yards from the Gothic quarter with its stupendous cathedral and from the noise and traffic of the Ramblas and the opulence of the Plaza Real. His father, Miguel Miró Adzerias, was a goldsmith and watchmaker whose art would, as we shall see, always have an

influence on Joan's work. His uncle was a blacksmith in the old village of Cornudella, half-way up a mountain in Tarragona in wild rough country – a scene from purgatory if not from hell. His father had come down to the swarming Mediterranean port of Barcelona from the country around Montroig, which lies hunched against the red mountains. Near Montroig and beyond Cornudella lie Ciurana and the hermitage of St Ramon, and Cambrils and Prades stand on the sea at the foot of the hills. These were the legendary places of Joan's childhood, the dream-like settings in which as a child and later as a boy he began to see and feel life and became aware of himself. For Leopardi, it was Recanti, for Virgil, the Mantuan countryside, for Raphael, the hills of Rome and the Palazzo Ducal and for Van Gogh, it was the countryside around Arles which was important. On the terraced hill-sides of Montroig, which run downwards like steps and form barricades around the stark mass of the old church, Miró found refuge as a silent, introverted boy and as the reflective poet he was to remain.

In direct contrast to the square-cut rocks of Montroig and its fields of hard-won soil, a land criss-crossed with walls like a chess-board, was the other dream-land, the other root of Miró's consciousness, a further source of energy and an outlet for unrestrained flights of fantasy, dreams and turbulent southern magic: Majorca, the mother country, the sun-soaked island which lies dazed and intoxicated in the Mediterranean. Sun and sea, cactus and aloe, donkeys and carts, flowers bursting from parched, cracked ground, and soil which needs only a bucket of water to produce miraculous plants of impossible colours and scents, Majorca, sweet as the Orient and as drowsy and violent as Africa – this was where the most beautiful days of Miró's youth were spent apart from Montroig.

Like Montroig, Majorca is one of the key places in his life, next to Barcelona where he went to school, first tried his hand at painting and began friendships which were fruitful though provincial and a little negative. But an artist's world is made up not just of what surrounds him but of everything that he finds interesting, curious or appealing. Every artist is a bit like a small boy seeing everything in his tiny world in the most minute detail, so that the simplest and most common thing can suddenly become a new miracle. Household objects, the massive forms of the trees which loom overhead, flowers, houses and everything a child notices and studies from the moment when he begins to look around – these things are his world. He may begin to put down what he has seen on paper and thus interpret these things with the affection or repulsion that they arouse in him. Later, too, he will continue to take note of them, and if he is an artist he will do this with a selectivity which is no longer irrational but is the result of careful contemplation. It is a painful filtering process which involves a struggle to see the object in its pure form and to isolate it from the great confused mess that surrounds it. The real and unique secret of the true poet is to be able to see with the clear unspoiled eyes of grown children and Miró, Klee, Kandinsky and Chagall may be said to have this ability, the latter two because, as Miró's contemporaries, they fought with him to grasp this unattainable child-like quality. Many emotions, suggestions, and isolated images were indelibly imprinted on Miró's memory, on the virgin wax of his sensibilities and on his child's mind. It is worth trying to pick out the clearer and more probable of these: the cave-paintings at Altamira; the Roman paintings and frescoes of Catalonia; the complex movements of the watches over which his father toiled; the iron wrought by his uncle, whose work still stands outside houses in Catalonia, etched black against the dazzling white walls; humorous little carved figures, polished by the centuries and the work of real ingenuity, made by craftsmen in Spain and above all in Majorca, which popularise the human and subtle qualities of Greco-Alexandrine statuettes from Tanagra.

These were the sources of inspiration which later came alive in Miró's work and were transfigured by his interpretation of them. He also took in the humbler objects of the countryside: tools, beasts, clumps of earth, milking-stools, shovels, spades, carts and farm machines; the flavours, colours

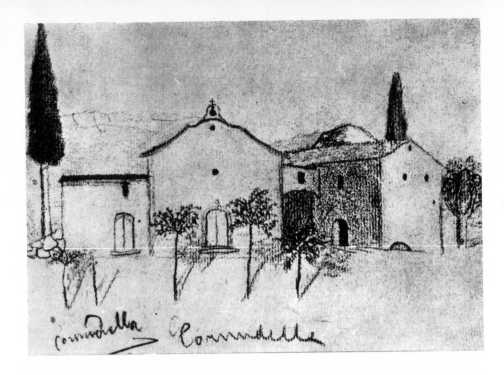

and silences of the countryside and – perhaps more important and significant – the open spaces, the neat geometrical sections into which the fields were divided with mathematical precision, like multi-coloured chequerwork or like music composed in colours. Above this hangs the sun, like the fiery swollen menace of the Catalonian and Majorcan sun, shining on to ancient churches, tiny lost villages, with their houses like small cubes, and on to rocky mountain slopes, hardening and strengthening, making plants flower and cracking the ground, making cacti grow into live fleshy monsters, like great humanised figures. Here the pitiless sun, as in ancient Egypt, is the source of everything. The same sun was to be reincarnated in Miró's work to shine again on tools, soil, plants, buds and flowers, on animals, taciturn peasants and on the black curls and spirals of wrought iron. A pale disc of liquid yellow or a live blood-clot of fiery red, this divine sun, interpreted as it had been in prehistoric cave-paintings, was later to reappear among the heiroglyphs of Miró's language, the magic calligraphy through which he finally gave expression to the stars, the constellations and the planets, as well as to the elements of his own world.

The Academia de la Lonja

Places and things, animals and objects were the young artist's principal sources of inspiration. Beyond this, Miró's adolescence was only an assimilation of emotions and impressions; the cataloguing of places, colours and things in the memory. His first drawings were precise and stringently realistic, really only exercises in calligraphy. It was a matter of coming closer to the things around him in order to learn about them and their real forms, to fix their image without adornment or fantasy. The pictures he drew between 1901 and 1905 were mere trifles – flowers, leaves and fishes such as any child would draw. He was surrounded by the countryside, the houses and rustic architectural shapes around Montroig and in Majorca. His early love of drawing naturally gave birth to the wish to go to school and learn how to draw. This gave rise to quarrels with his father, a solid working man of a commercial turn of mind who wanted him to aim at a more practical career, towards a job with a more secure future. He enrolled for three long years at a school with a commercial bias, but at the same time he followed courses at the School of Fine Arts at La Lonja, where the studies were coldly objective and highly practical, being intended as a training for engravers, decorators and exponents of the applied arts. These courses served Miró well, for in them he learnt to discipline his work, developed his technique and got to know the tools of his trade, which played an important part in Miró's later painting. But the teaching at La Lonja was academic and traditional and the

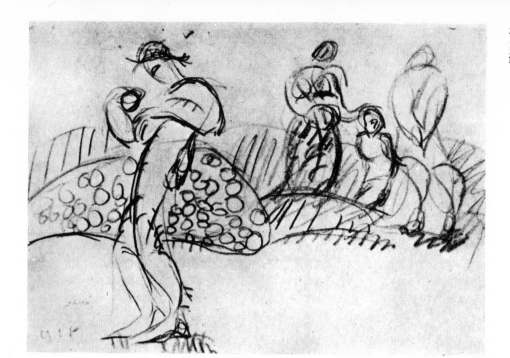

2. *Figures*
1915, pencil drawing done on a bench
in the port of Barcelona

exercises he did there were no more than laboured and mediocre.

Ten years earlier another young man of altogether different temperament
had passed through those same doors. He had earned the admiration of all,
had drawn better than the teachers themselves and had won all the prizes–
a young man who had left amid universal acclaim–Pablo Picasso. Miró was
quite unlike him; he was slow to learn and did not know how to dissemble
or to take the rough with the smooth. He was neither a quick-change artist
nor a mimic and he endured the environment in which he lived instead of
adapting himself to it or to the mood of the moment or of the company.

Even La Lonja, however, played a positive role in his life. It was here that
Miró met Urgell and Pasco, his teachers, with whom he afterwards remained
in close contact. Urgell had been influenced by Böchlin and the Pre-
Raphaelites and his landscapes were saturated with Romanticism; Pasco
inspired in Miró a love for the applied and decorative arts–ceramics,
cabinet-making and jewellery–without leading him to lose his individuality.
The stylisation and craftsman-like precision involved in the art of designing
for jewellery, textiles and wrought iron in Miró's mind, giving him a facility
for fine work and also the ability to find a motif which summarised and con-
centrated many words and lines in a single concept. There is no doubt that
his motifs will never be repeated in mass-produced series. His leisure time
was spent freely drawing in the countryside at Cornudella, the gnarled, rustic
half-world that was closest to his heart.

A ring of eyes round the head

In 1910, when he was seventeen, his commercial studies ended in disaster,
but his father was adamant and insisted that he should make a practical start
in life. So for two years Miró worked as an accounts clerk with the firm of
Oliveras, a big commercial concern in Barcelona. It is hardly surprising that
these were the most bitter and tragic years of his life. His misery culminated
in a nervous breakdown, followed by an attack of typhoid fever as a result of
which, and by way of compensation, he had a long period of convalescence
in the solitude of Montroig and in touch with nature. His return to health
brought with it new strength and resolution. He would have no more to do
with jobs, commerce or bourgeois careers, and on his return to Barcelona,
he enrolled at Francisco Gali's school of art, which offered far more liberal
and lively teaching than he had had at La Lonja, and gave him three forma-
tive years of experiment and trial as well as a number of friends. It was here
that he came to know and love the work of the Impressionists and painters
like Van Gogh, Gauguin and Cézanne, and it was here, too, that he came into
contact with the *avant-garde* movements, Fauvism and Cubism. This was his

initiation into a world that was to become his own: talking about art and other painters, learning about music and going to concerts given by the various musical societies; exchanging ideas and making excursions with his friends and his teacher, Gali, into the mountains of Tarragona which he already knew so well; never sketching or taking notes, but retaining everything in his memory and, on Gali's advice, 'having a ring of eyes round his head'.

Gali understood Miró's peculiar and paradoxical character. To help him get a grasp of form and volume, he made him blindfold his eyes and draw objects and heads which he had felt but not seen. This exercise was to serve him in very good stead in the future. The years 1912–15 were years of apprenticeship, during which he formed an important relationship – his friendship with Manuel Grau, the historian of Catalan art, who rescued and conserved the most interesting Romanesque frescoes in Catalonia. Besides Grau, another friend joined him in his researches – Ricart, with whom he has corresponded all his life and who became his closest confidant in Paris. With Ricart he had many a passionate argument, and with him and his friends he visited the gallery owned by Dalmau, the businessman who first introduced the work of the Cubists into Barcelona, and who was also the first to exhibit paintings by the young Miró. After his schooling at Gali's, which had still been essentially technical and practical, and with his new friend and new skills, Miró decided to undergo one further stage of preparation with the St Lluch Circle and for two years, up to 1917, he painted nudes and did drawings in charcoal and red chalk. It was in this work that his desire for plastic realism, his urge to find the key to movement and to life, found expression, resulting in the violent and resolute style of these years. In his notebooks we find nudes drawn with great precision, heavily built figures with powerful curves, their contours hewn into relief as if they had been carved out of a tree. At other times his nudes are evanescent phantoms, summoned to the light of day as if by magic.

A feeling for colour

In his first oil-painting, Miró's colours burst out in great flashes, reminiscent of flowers in the soil of Tarragona. Colour, which he had previously used only in water-colour to heighten a drawing, now dominated his painting and gave it its form in a way unique to Miró, as exemplified in a painting of 1912 (if the date it bears is correct), called *The Peasant*. Here the central character is blurred, submerged in a deluge of colour – a whirlpool in the shape of a man. Miró was clearly under the influence of Fauvism. The lyrical violence of his colours is unbridled: crammed into the narrow confines of a frame which cages them together, their broad transverse strokes meet in brilliant clashes. Mediterranean light, colours and temperament are clearly reflected in these warm, vibrant and flamboyant paintings.

Then, from 1914 on, Miró put his skill to the test with subjects from the countryside. His aim was to explain in colours the feel of those scenes he had recorded in earlier years in simple charcoal drawings. Thus there emerged *Montroig Landscape* of 1914, *Maria of Montroig* and *Roadman's Cottage,* fragments of his country, which he tried to paint by means of *pointilliste* dabs and close, thick and heavy strokes, producing an effect of overloading and confusion which betrayed his exertion. Another year of experiment was to pass before he achieved his first satisfying canvases: *The Reformation, Barcelona, St Ramon of Montroig, Landscape at St Martin* and finally *Landscape at Montroig* and *Village of Montroig*. A subterranean energy infuses the countryside, the tiny houses, the skies suspended high above, the pointed rocks and sparse plants – a sort of leaven which frees them from the dictates of geometry, despite the painter's desire to reduce them to a system. Houses, rocks and skies come through more strongly than he had intended in a free fantasy which he could not subdue, producing a profoundly disturbed representation of reality. 'Miró is and always will be the inspired painter *par excellence',* wrote Dupin some years later – and we can only agree. As an inspired painter, his work is by nature subject to fluctuations in quality and standard from one

Pl. 1

painting to the next: either one of his paintings has it all, or it has nothing. There is no mediocre.

The volcanic flow of the Montroig houses seems scarcely to have solidified following an eruption. It looks like hot lava, still glowing with living matter beneath a streak of sky spotted with yellow, red and green dots like pebbles suspended in mid-air after the explosion. Miró's first still-lifes are more coherent and have an altogether more accentuated use of colour than his landscapes. The still-lifes have a powerful three-dimensional quality and outline and colour are perfectly combined. The subjects are all caught up in the same rhythm. Grotesque, comic, like dramatic personages, they move, dance, yawn and twist, touched by the fever Miró projected and by his own spontaneous outbursts. The objects are depicted in perpetual and reciprocal dialogue. Miró's reputation for being silent and shy is doubtless because he does not feel moved to speak directly. He speaks through things, through the characters he creates, because they can speak for him and say the words he cannot find. In *Clock and Lamp,* the dialogue is not just between the two major characters–everything moves: the wall, the background, the fruit and the drapery on which the objects lie. It is as if the painter was not able to subdue the real and autonomous life that objects have, and which only the artist can capture. These are still-lifes which take after Cézanne but which arrive at an entirely opposite effect, having none of the architectural rigour and crystalline hardness of Cézanne's pictures. In their passionate violence and their tangling and untangling, they are closer if anything to Matisse's painting, and echo the titanic struggles and drama of Van Gogh. All this is present in the bottles, vases and fruit dishes standing among the mounds of tablecloths and drapes which lie on the rough surface of a small table outlined against a blurred horizon, objects which are in no way stable, though clearly and deliberately drawn. They are alive because of their pulse, their sparkling and unstable colours, their bursting desire to exist and to be depicted in terms of theatre, striving to assert themselves and charged with life like the flame a candle which flickers and burns with all its strength before spending itself and going out.

Then, at the end of 1915, having achieved his first satisfying though not entirely positive results, Miró decided to continue along the lines on which

Pl. 3

Pl. 2

An ancient heritage

he had started and committed himself by taking his first studio, which he shared with a man who became his friend and with whom he shared both hopes and disillusions. The first studio is of primary significance to any artist, but it was particularly so for Miró who found it so difficult to convince himself of his own value and who had been so hesitant and afraid of taking this great step. 'I do not possess the ability for three-dimensional effect; this makes me suffer terribly and I sometimes beat my head against the wall in desperation.' These are the words in which he expressed the emotions he felt during those months of toil and struggle. To complicate his life further at so critical a time came military service. He managed to do it at Barcelona, which was a stroke of good fortune for he could then paint in his spare moments, in his off-duty hours or on his short leaves, sitting at his easel in his uniform. This was the great turning-point in his liberation from the ties and influences of his family background. He plunged whole-heartedly into the new circle of the poets and painters of his generation, of which there was an active and lively group in Barcelona. Their headquarters was the Dalmau Gallery, where they discussed and admired the first Picassos, Légers and Duchamps and sought to escape from the fetters of provincialism and of the local schools and academies. He got to know the local painters, well-known, honest artists who were revered like demi-gods, but who at this time were tied up with a passion for prehistory, which only the new works from Paris could shake, bringing them into the present and introducing them to a language and form of expression which mirrored a new concept and a different sensibility.

These were also the years of the Great War, which was being fought in France, Italy and Austria and could not be ignored in Spain. It was a war which involved all Europe, and artists from all over the world found themselves at the front, telling each other about the new ideas amid the din of gunfire. The paintings of French and Italian artists at the front soon began to be seen in Barcelona, and the pages of the newspapers bore extracts from the books and poetry of the new generation. It was a war of ideas, and it caused a revolution right at the roots of the world of painting.

In 1917, one of the foremost figures of the Dadaist movement, Francis Picabia, arrived in Barcelona with the first numbers of the *391 Review,* which had been started in New York by Picabia and Marcel Duchamp. Another arrival was Max Jacob, the critic who could spell success or oblivion for a modern painter and who, according to a sharp observation by Anselmo Bucci, 'explained to Picasso what Picasso was painting'. Along with *avant-garde* reviews like *Nord-Sud,* which featured in one of Miró's paintings, and the poetry of Apollinaire and Cendras, Barcelona became suffused with the spirit of Paris and its worldly artistic atmosphere. From Paris arrived the echo of artistic and literary shocks and scandals, for it was there that De Chirico pioneered metaphysical painting and Cubism was born. What was Cubism? Max Jacob explained it as: 'The making of a picture which is neither anecdote, chronicle, sonnet, romance, saga, nor object–none of the things, in fact, which has hitherto been painted–but still a picture'. And the latest dainty morsel of scandal about Picasso had just arrived: he had painted a female nude exactly like Ingres' *La Source,* had shown this painting to his friends, and then had picked up his spatula, cut the painting to ribbons and burned it on the stove in front of everybody. Any gallery in Paris would have paid through the nose for a nude like the one Picasso had painted and destroyed, but he knew and said that it was dead, an anachronism, that he did not want to be the prisoner of a false language of expression and that it was necessary to destroy in order to create and to die in order to be reborn, in the same way as the human race renewed itself after the flood.

Simultaneously with this desire for innovation in painting came a parallel burst for innovation in poetry. The importance of poetry to Miró and his work cannot be over-emphasised. He was deeply involved with poetry and poets throughout his time in Barcelona, his years of preparation and his entire productive life. The community of poets in Barcelona gave him a foretaste

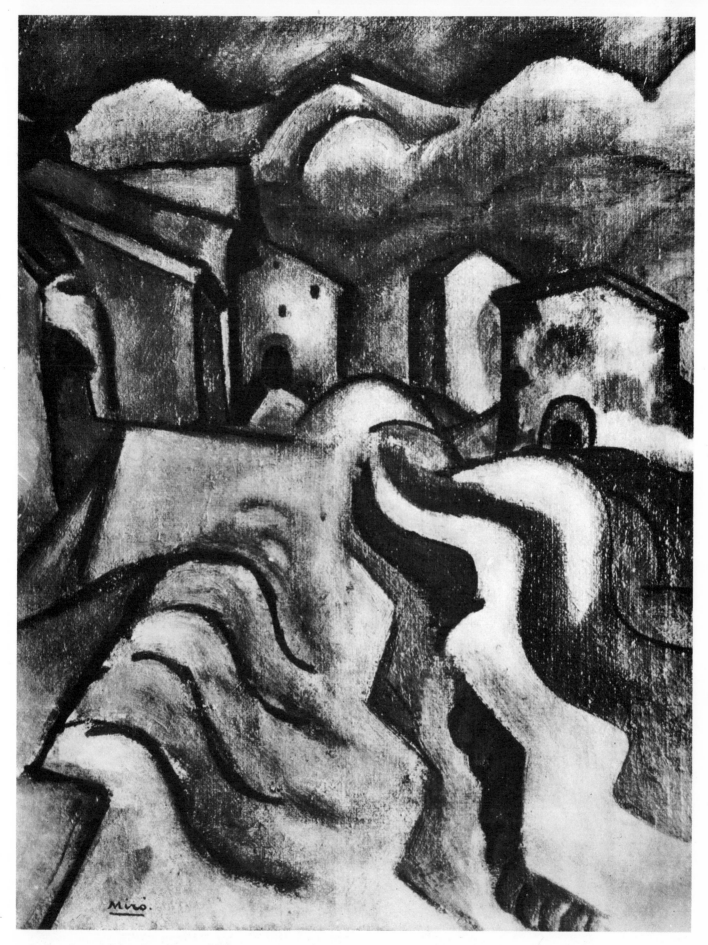

of what was to be offered him in post-war Paris.

In 1916, after a long period of hard work in his first studio, Miró at last exhibited his paintings to the public at the Dalmau Gallery, the scene of much inspired idea-swopping between the exponents of the *nouvelle vague* in Barcelona. Life in Barcelona gave Miró not only his first contact with the public but also the opportunity of discussing ideas with his friends and com-

4. *Village and Street, Ciurana*
1917, oil on canvas
$15\frac{1}{2} \times 19\frac{1}{4}$ in (39 × 49 cm)
Joaquim Gorris collection,
Barcelona

paring their aims, their drawings and their poetry with his own. But from time to time, the silent and profound dialogue with himself which had begun in his childhood was continued in the country, among his mountains and in the familiar solitude of nature. There he could assemble his thoughts and get outside influences into perspective. At the same time he would paint the things that were crying to get out. He relaxed, pondered and was himself again.

'I have come to live with the country for a few days in order to commune with the blue and gilded light of the cornfields and to exalt my spirit at the sight of them,' he wrote to his friend Ricart. In another letter he talks about 'the solitary life at Ciurana, the marvellously primitive nature of the people, the intense work, spiritual contemplation and the possibility of living in a world created by my isolated spirit, like Dante, far from all material realities' – these were the things he was really looking for. The countryside of Ciurana was in his blood, a part of him, and it became the life-blood of the beautiful

Fig. 4

landscapes which he painted between 1916 and 1917: *The Church, Ciurana; Village and Street, Ciurana; Village of Prades; Street at Prades;* and finally,

Pl. 5

perhaps the most significant canvas of this period– *The Path, Ciurana.* It represents the triumph of Catalan Fauvism and also of his personal brand of Fauvism: so personal is Miró's interpretation of contemporary movements and fashions that he always remains on the fringe of any such developments, and if he takes, he always gives something back. An extraordinary desire for clarity and an ever more distinct tendency towards simplification are visible in these landscapes, with the result that they are less turbulent and volcanic than previous ones. Painted with a more measured sense of space and volume and with a definite rhythm, houses, people, villages, streets and the land, with its furrows and arid fields, all maintain their movement and essential structures, though geometrised and schematised. Clearly articulated in this way, everything is made brighter and clearer. His landscapes are totally revitalised and assume a startling actuality. Everything is translated into a rhythm of colours, like the translation of musical waves into a diagram of colours, with ever more varied and fleeting modulations, in search of a particular harmony. These are the various combinations of the moment, arranged in a brilliant kaleidoscope–maize yellows, acid-tinged, and violent greens, simulating nature's explosions of growth, are streaked, splintered and dramatically interlocked; all this lies beneath a motionless, azure, ancient sky hanging over a world which has been totally fragmented and modernised. This is the sky that we find in *The Path, Ciurana,* which, along with the *Village of Prades,* typifies this period and these techniques.

In quite a different mood are two very delicate, airy and windswept views of the sea at Cambrils, where figures and shadows whirl around each other like phantoms beneath an implacable and blinding sun, the classic Mediterranean sun of Majorca. The figures bear no relation to conventional repre-

5. *The Bridge, Montroig*
1917, oil on canvas

6. *The River, Montroig*
1917, oil on canvas

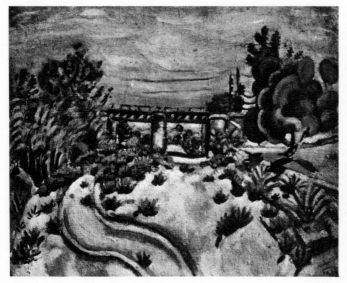

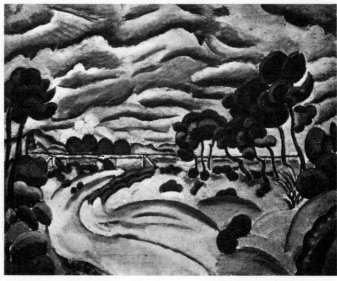

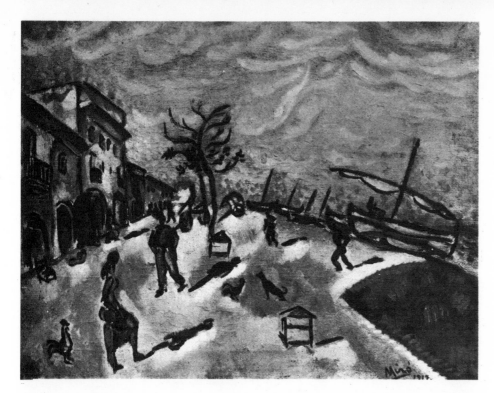

sentations of the human form and in fact mark a nascent crisis in Miró's Fig. 7
representation of the human figure, which was to culminate in a complete
break from accepted tradition.

Miró's two distinct approaches to landscape are clearly contrasted in two
versions of *Bridge at Montroig*. In the first, every tree, bush or cloud is repro- Figs. 5, 6
duced with punctilious precision. In the second, individual fronds and
branches have become masses, clouds are luminous recurring waves and
trees have become geometrical stylisations.

The harsh landscape and cracked earth of Tarragona are seen again, with
the same chromatic explosions, in the still-lifes of these years. *The Blue Bottle* Pl. 4
is an excellent example: a sea of entirely subjective interpretation envelops
the objects; the bottle, fruit and fruit-dish are trapped in solidified streams of
lava which flow along the angles of the table, reflected in a play of recurring
waves stretching to the background of the picture where red, orange and
green fade away to the left against a triangle of sombre azure, like a halo, over
the bottle. The vigour and explosiveness of this dialogue between the painter
and his subject is also evident in the portraits of this period, the only ones he
ever painted. These were dialogues between Miró and people he actually
knew: the first was a self-portrait; others were portraits of his friends, Ricart Fig. 8
and Rafols, a portrait called *The Chauffeur* and the *Portrait of Juanita Obrador*. Fig. 9
In the portrait of Ricart, the complex marquetry of the fabric gives an effect
reminiscent of a Byzantine miniature, in colours which recall the preciosity
of an enamel. In the background, however, an immensely intricate Japanese
engraving shows Miró's love for the infinitely small and refined, for the
elegance of the Liberty flourish, but translated into a personal vocabulary, as
in a Matisse. On the left, an area of pure yellow, on which the shape of a
palette is summarised by a sort of abbreviation in his language, anticipates
the ciphers and abbreviations of his mature period and his ultimate develop-
ment as a painter. The head, like a landscape, is broken down into its funda-
mental masses, as are the disjointed hands, suddenly calling to mind the carved
faces and hands of the Romanesque saints found in the ancient churches of
Catalonia, which his friend, José Pasco, had shown him. Miró had stared
intently at these monumental figures built into the walls of churches and had
learnt from them a lesson in Catalan Romanesque. The bold synthesis in
which he defines the different planes of the portraits and crystallises move-
ments and gestures; his desire to mark or emphasise certain anatomical
details and the rhythmic play between the figures and their backgrounds – all
are reminiscent of the disciplined work of the Romanesque artist. There is a

8. *Portrait of E. C. Ricart*
1917, oil with print stuck on canvas
$31\frac{7}{8} \times 25\frac{5}{8}$ in (81 × 65 cm)
Samuel A. Marx collection,
Chicago

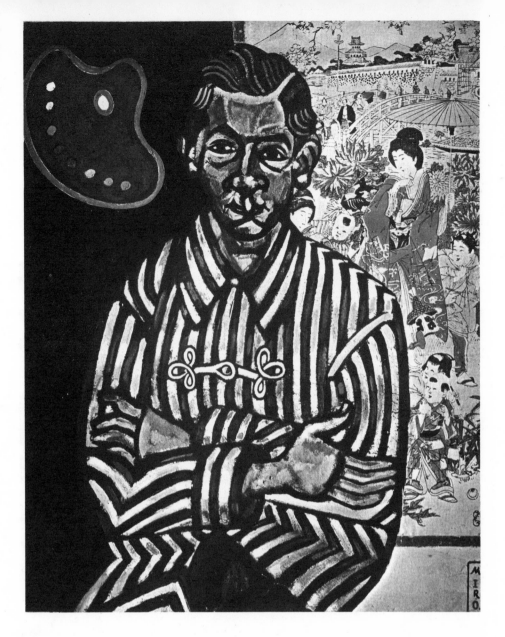

parallel too with certain aspects of Picasso's drawing which is allied, whether consciously or unconsciously, with that of classical fresco painters: the trifoliate noses, the big swollen mouths, the wide staring eyes, unflinching in their perpetual fixity; above all the extraordinary monumentality that Picasso's characters display, the ingredient of the macabre and grotesque, of the humorous and ineluctable. These are elements which, stemming from pre-medieval Spain, are found again in Picasso's Spain.

Pl. 6 This derivation is also clearly evident in Miró's beautiful *Nude with Bare Feet* of 1918, one of the key pictures before his 'revelation' – the moment when he began to understand his most secret inner world. Like an odelisque nude, she stands on a carpet *à la Matisse* in front of a drape which, with its Miró-style Liberty print, at once conflicts with and orientalises the central figure. Instead of blending into the tortuous and resplendent landscape of these fabrics, she forces herself into the picture with a burst of energy, as dynamic as Catalonia. Hers is a hard angular figure, carved out of stone, and as resilient as a suit of armour. The power and heaviness of the body are dominated and compensated by the thoughtful, dramatic face, which seems to interact with the design on the hangings and yet seems independent of them, as well as of the heavy-handed presentation of her powerful body. And the eyes, unutterably sad and poignant, are like those of certain Romanesque figures of Christ, which stand isolated and lost in the spacious emptiness of churches. In this painting, therefore, the Byzantine contrasting of different patterns and textures is far from being just abstract and meaningless decoration and in fact exerts an expressive force and contributes to the

depiction of the character itself.

In the *Portrait of Juanita Obrador* there is again this interplay, though more accentuated, between the pattern on the woman's dress and the contrasting pattern on the wall behind, from where the metallic mask of the face looks out fixedly, like that of an Oriental idol. Here, however, this contrast is set in an entirely Mediterranean and Western context. Here, too, we see how Miró's own identity marks every subject he paints.

This introductory phase was followed, before his complete break from traditionalism, by a period which has been called 'poetic realism', which characterises all his paintings between 1918 and 1922 and in fact culminates in the painting that was the basis from which he ultimately moved towards his own highly individual language, *Ploughed Earth, Montroig*. This painting,

9. *Portrait of Juanita Obrador*
1917 (?), oil on canvas
$27\frac{1}{2} \times 24\frac{1}{2}$ in (70 × 62 cm)
Joseph Winternothan collection,
Art Institute of Chicago

Fig. 9

A geometrical record

Fig. 19

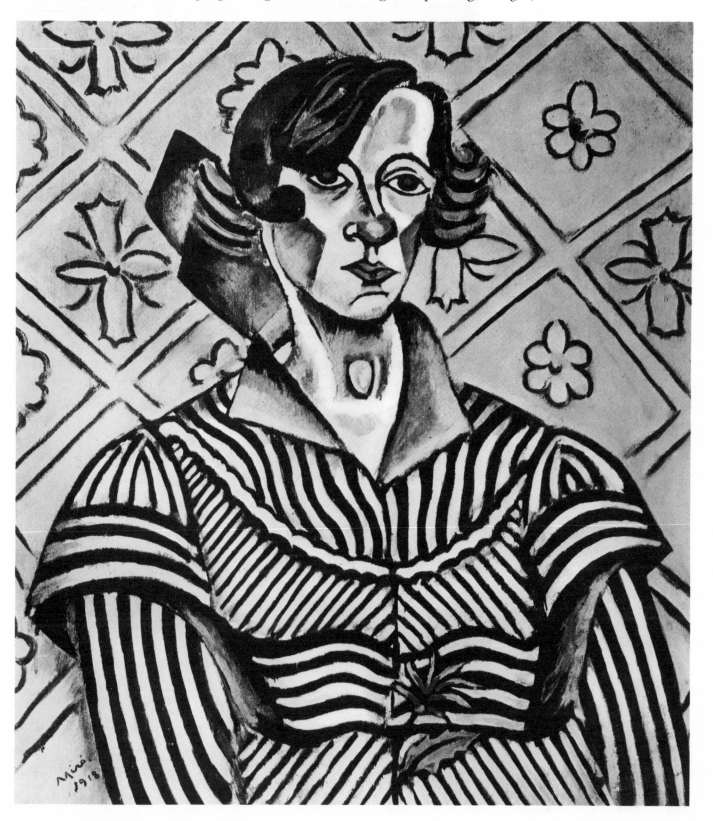

10. *House with Palm*
1918, oil on canvas
Private collection,
Barcelona

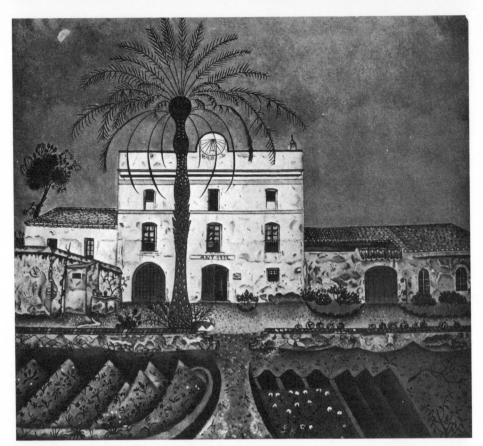

11. *Vines and Olive-trees at Montroig*
1919, oil on canvas
$28\frac{3}{8} \times 35\frac{1}{2}$ in $(72 \times 90$ cm)
Leigh B. Block collection, Chicago

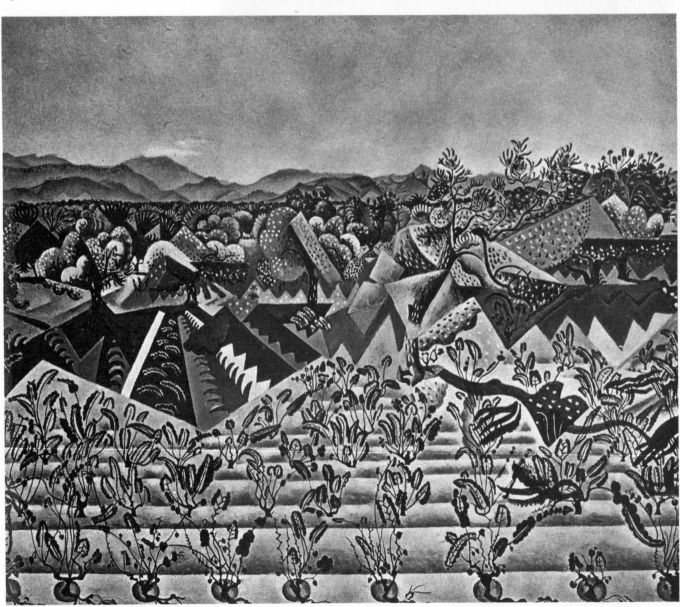

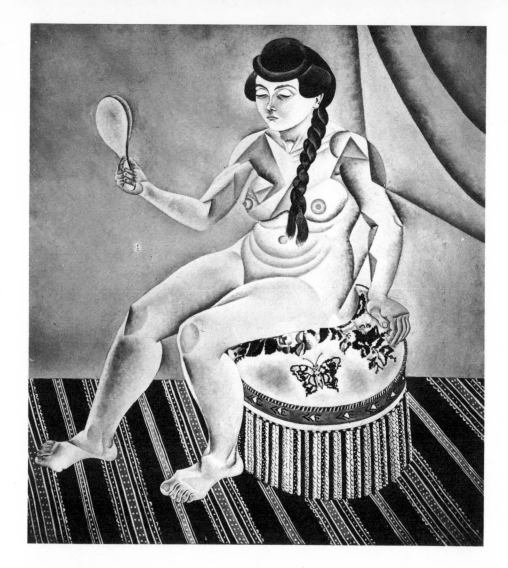

12. *Nude with Mirror*
1919, oil on canvas
$44\frac{1}{8} \times 40\frac{1}{4}$ in (112×102 cm)
Pierre Matisse collection,
New York

as we shall see, signalled a point of arrival and also a point of departure. From here on, Miró worked towards his later free compositions of 1933 onwards.

After the terrible winter of 1919, he went back to Montroig to his own world, to the objects, movements, sounds and lights which had been an integral part of his childhood. Even amid the hubbub and chaos of his first contact with Paris, these things had occupied a sacred and secret corner of his mind; now he went back and devoted himself entirely to them. Rediscovering them, he caressed them with his gaze, trying to recapture them for the last time on canvas, as if he was clinging tenaciously to the reality they represented with all the love and dedication of one who, standing at a crossroads in his career, feels a part of his life slipping away. Everything was depicted with great precision, as in an engraving, and according to the strictest geometrical rules. As has been said, and as he himself was to recognise later, he showed an affinity with Japanese draughtsmen, who made an important artistic language out of their calligraphy; Miró stood before things and translated them, with the same love and respect, into his own minute, magic and reverent interpretations. 'What interests me'—he said in a letter to Ricart—'is the calligraphy of a tree, of tiles on a roof, and so on, leaf by leaf, stroke by stroke, blade of grass by blade of grass.' Every element and every object is studied obsessively, translated into a note on his sketch-pad and later harmoniously incorporated into a painting, like part of a symphonic score, or a component in a mechanical system. It is of some significance that he was the son of a goldsmith and clockmaker; he must have inherited the mania for order which has always characterised his private life and habits. Miró cleans and rearranges his brushes every time he uses them and leaves his studio as spick and span as a chemist's laboratory or an engineer's workshop. Perhaps this tendency is connected with his desire for spiritual order, for a sort of

syntax within which to organise the dialogue of the material world in life as in painting.

Fig. 10 The *House with Palm* of 1918 is typical of this love of detail taken to extremes. The palm is a little off centre, standing in front of a white house, a farmhouse, in the countryside of Catalonia, like any other in Puglia, Calabria or anywhere in the Mediterranean. If this palm-tree were removed from the picture it would have the same decorative splendour and musical elegance as the palms in Byzantine mosaics, like those we find in the procession of the virgins of St Apollinaire. Around the palm-tree, every furrow, plant and leaf is hammered out and polished in the tempered iron of his painting and his poetic language.

Miró's religious standpoint, a blind, extravagant, emotional and absolute adoration, is reminiscent of Van Gogh's, except that the latter seems to have been totally involved in stormy and violent emotions. Miró recreated the objects of his adoration, his fields and earth, with almost monastic patience. While remaining faithful to the reproduction of detail, he sought to arrive at a stage where he could suggest detail by means of abbreviations. Thus every brush-stroke in *House with Palm, Orchard with Donkey* or *Brick-kiln,* ending Fig. 11 with that masterpiece, *Vines and Olive-trees at Montroig,* is drawn with the same patience that the peasant uses to subjugate the soil. Thus the earth, all ridges and furrows and divided into angles, sections and parallels, echoes the rhythm of the peasant's toil, which is like Miró's, having the same stubborn constancy and the same silent, almost secretive love.

Fig. 11 In *Vines and Olive-trees at Montroig,* the line of mountains in the background is reminiscent of certain Japanese water-colours and the collage of the foreground and the other planes, with their fragments and stripes of pure colour, recall the patient enumeration of detail seen in certain Persian miniatures and the geometry of those Oriental carpets and fabrics, where the curls and leaves of a plant are the more fabulous for being transmuted straight from reality. Many hours of patient experiment must have gone into a picture like *Church at Montroig,* where every window, every stone of the old church and every crack in the wall may be found in the real thing. It is a complex draft which preludes the masterpiece of these years, his canvas, Fig. 17 *Farmhouse,* on which he was to work for two years, twice returning to it.

Fig. 12 Like *Church at Montroig, Nude with Mirror* of 1919 is pure structure, built up of simplified planes and masses resembling a Cubist interpretation by Picasso. In both of these paintings there is the same basic analytical geometrisation of certain Catalonian painting, which reappeared as the basis of his new research. Like some medieval figure of Christ by Coppo di Marcovaldo or Cimabue, the powerful outline of her body standing out against a ground of extravagant decoration, the figure in *Nude with Mirror* projects her hard and metallic form from the striped carpet and the flowered stool. She stands like the symbol of a new race–idol of a promised land, goddess of perdition, enthroned on her grandmother's *petit-point* stool. The Cubist influence is very clear and helped Miró to heighten in this figure the impression of an automaton or religious robot. Her orientalised face has an impenetrably enigmatic expression; the attitude of the figure with the mirror in one hand, is equally enigmatic. Firmly planted on her two enormous buttocks, she is almost a symbolic representation of woman, with all the mystery, sensuality and plenitude that woman, the life-force, implies. This is a statue to woman, an architectural representation of woman, all the more imposing for being presented on a refined and highly elaborate pedestal against a ground of dull ancient red, which approaches the red of certain Romanesque frescoes in Catalonia.

Dialogues with himself

Fig. 13 Closely related to *Nude with Mirror* and almost contemporary with it was the famous *Self-portrait,* bought by Picasso and still jealously treasured in his collection. In Paris this latest arrival from Barcelona needed some support, someone to lean on in the labyrinth of the metropolis with its infinitely varied attitudes and cliques. The far-sighted and perspicacious eye of Picasso saw

that this canvas deserved his attention and, as a friend and compatriot, he took Miró under his wing and thus opened up for him a new market and made it possible for him to become more widely known. The search for a robust subject, boldly outlined and real in plastic terms, already begun in the Montroig landscapes of the previous summer, is clearly visible in this *Self-portrait* where we once again find a wealth of detail and a refinement worthy of a miniature. Miró interrogated himself mercilessly in a courageous shouting match with the self that looked back at him from his mirror. Certainly

13. *Self-portrait*
1919, oil on canvas
$51\frac{1}{4} \times 43\frac{1}{4}$ in (130×110 cm)
Pablo Picasso collection,
Vanvenargues

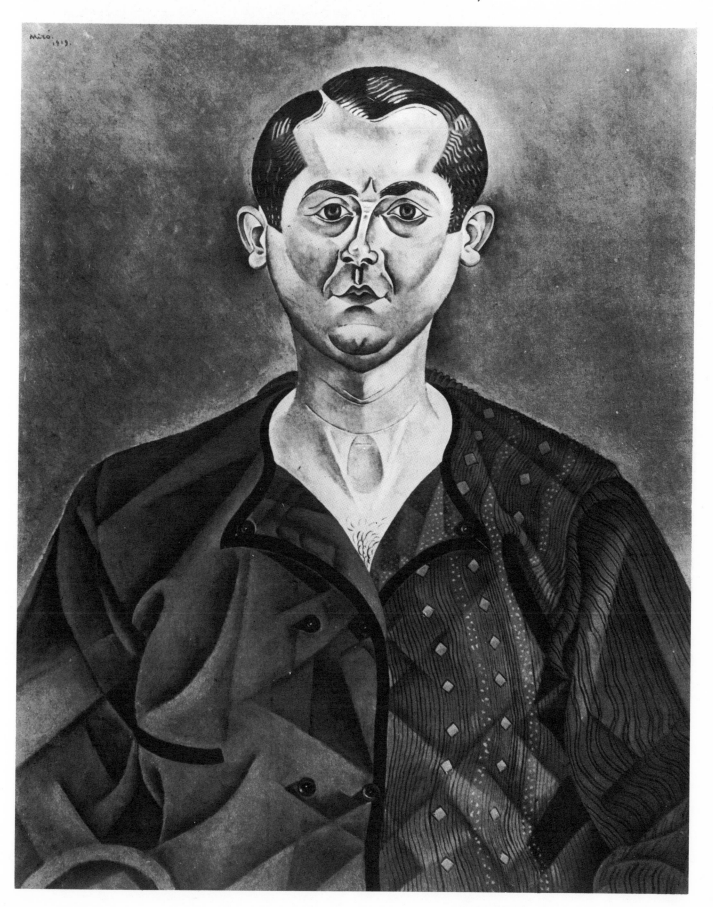

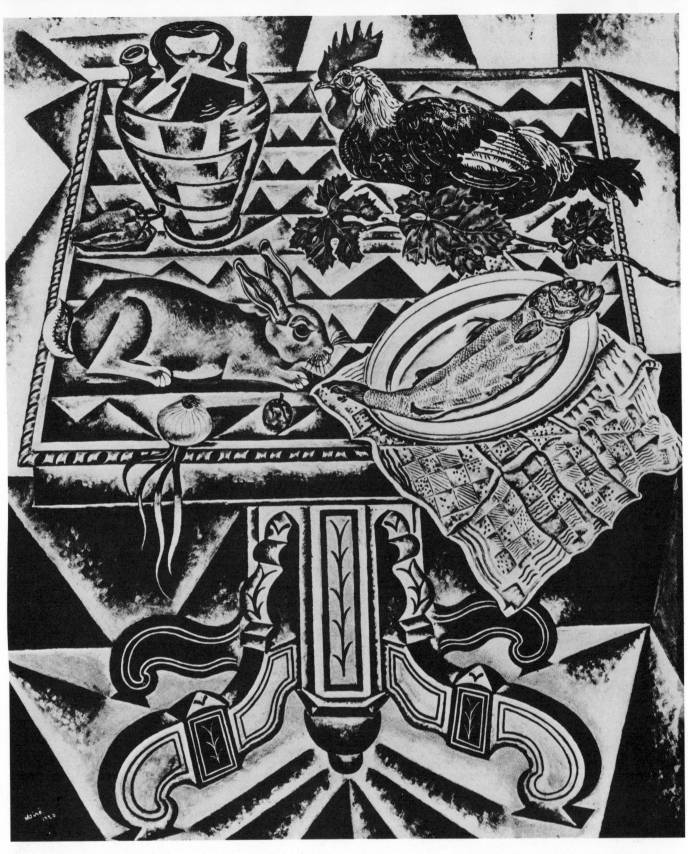

14. *Still-life with Rabbit*
1920, oil on canvas
$51\frac{1}{4} \times 43\frac{1}{4}$ in (130 × 110 cm)
Gustav Zumsteg collection,
Zurich

the objective search for reality and truth is clearly evident in the beauty of this picture. Impressive in its severity, his look of being above the conversation or lost in a nirvana is almost that of the figure of Christ at Tahull which looks out from the apse. There are some points of contact here with Cubism which emerges as the discipline of the work and was clearly a means of grasping the image more firmly; other aspects of the portrait are equally clearly inspired by Romanesque frescoes, so that one sees how Miró had absorbed the lessons both of Cubism and of Romanesque painting. It is interesting to see how far Miró exploited both Cubism and Romanesque art only in so far as he needed them. The early days of the Cubist movement, when Picasso and Braque discovered the interrelations and structures which towards 1918

they were already discounting, had already been left far behind; and Romanesque art was far off in terms of time. Nevertheless, a certain Romanesque gravity acts as a sort of sub-stratum in this self-portrait, a sign of maturity in the crisis which threatened.

We have now reached the period during which Miró arrived at the kernel of his work as an artist. This was a time of stupendous discovery. In the first place, he found strength within himself which had been tested in his first hard-fought battles; he discovered the adventure of Cubism of which he had learnt nothing in the peripheral existence of Barcelona, even though it was now a fading star; he also found friends in Paris and got to know the studios of the artists in his neighbourhood. The work of the Impressionists, of which he saw a great quantity in Paris, made a profound impression on him, though only as a style of painting which had already become history. This was a sign of his unshakeably modern approach. 'The French tradition lies in little pieces. The Impressionists' storm of colour and light, captured by Cézanne – though only, it seems, for museum walls – is now over.' It was the time for research and for voracious and patient study. He wanted a studio of his own and, towards the end of 1920, he found one. It belonged to the sculptor, Gargallo, who taught in Barcelona in the winter months and therefore left it vacant during the months when Miró was in Paris. It was at 45, rue Blomet, near Montparnasse and the Seine, in a district highly evocative of old Paris. It was from this moment that he began to make his most important friendships; he became a close friend of André Masson, knew Max Jacob, and made a number of friends among the group who lived in rue Blomet, later to be reunited in André Breton's Surrealist movement, out of which Miró's personal brand of Surrealism was to grow. He later wrote 'Times were hard. The windows were broken and the stove, for which I had paid 45 francs at the Fleamarket, did not work. However, the studio was sparkling clean, and I cleaned it myself. And as I was very poor I could only afford to give myself one meal a week'.

This heroic period produced a whole series of still-lifes, *Horse, Pipe and Red Flower*; *Still-life with Rabbit*; *Table with Glove* – canvases in which an extreme,

15. *Portrait of a Spanish Dancer*
1921, oil on canvas
Pablo Picasso collection,
Vanvenargues

16. *Spanish Dancer*
1921, oil on black card
$41\frac{1}{4} \times 29\frac{1}{8}$ in (105×74 cm)
J. B. Urvater collection, Brussels

The nature of things
Fig. 14

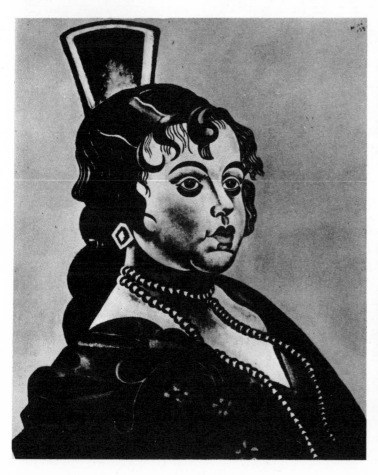

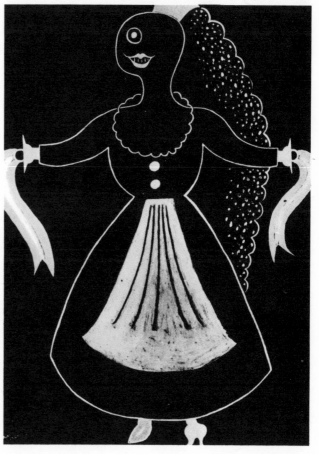

elaborate and exhaustive realism produces results which are the less real for his ever-increasing efforts to get inside his subject. Every object is splintered into the minutest detail, every part of the reality is caressed with love and obstinate fidelity; the little horse, looking like its counterpart on a merry-go-round, the vase, the glove, the fish lying on a plate on the ridiculous nineteenth-century table with its pretentious legs, the rabbit posing on the table and the flower in the vase – all these things are thrown together in an ensemble which has no perspective or third dimension and looks as if it has been flattened by a steamroller. Miró composed these collages of real objects without giving them any space to live or breathe. He jumbled and crowded them as in a nightmare. They cannot escape or go back to their natural environments, and this leaves an impression of the sense of sadness and futility in the painter's mind. The colours in these still-lifes are particularly interesting; they are vivid and faceted like mosaics, producing an effect analogous with that of certain mosaics by his compatriot, Gaudi, who produced the fantastic and original creations which can be found in the park at Barcelona. Just as the fabrics, draperies and flowers had served as collages for the Romanesque structuring of *Nude with Mirror* and *Nude with Bare Feet,* here the corners, angles and faceting of Cubist painting served as a thread connecting him with his desperate search for tactile reality, his aim to depict his subjects in a kaleidoscope of colours in which they seem permanently fixed but, in fact, they look sterilised and mummified. He had succeeded so well in mummifying reality that it no longer had anything to say. Miró could already smell the stagnation and sterility of this approach. On other occasions, as in *Table with Glove,* he achieved a simplification which produced a cold and studied effect; his pictures lost the bursts of Mediterranean colours and finally looked curiously like Léger's work. It was a final attempt to grasp hold of reality, the objective which he had pursued since the first fiery landscapes of Montroig and Ciurana. Soon he was to begin to seek an alternative means of expression and to repudiate the reality which had obsessed him by avoiding it and giving the 'idea of things' rather than a straightforward representation of them.

This new approach can be seen in the two portraits of a Spanish dancer, both painted in 1921. The first, which is in Picasso's collection, gives the impression of a head in hard and sculpted relief, the features cast in a mould. Her face looks like a mask which is in a way subordinate to the decoration on her dress. The second dancer on the other hand displays a freer treatment, based on instinct and lying at the root of all painting. We see her silhouette, an outline which even primitive man could draw. There is a certain amount of humour in this depiction, a feeling that it is a caricature which in one stroke sums up the spirit of the subject without the often useless detail which complicates the basic concept and shrouds it in a sort of fog. 'Painting must be killed for good,' he said, and started on this task, intending to annihilate not painting itself, but the stale and stereotyped myth which painting had until then perpetuated. He was now really close to his moment of liberation.

The Farmhouse painting

His final act of love for reality, which fermented and was filtered in the still of his mind – his last poem to his country and his childhood, like a thread joining the old Miró to the new – was his famous *Farmhouse*. Begun in 1920, but not finished till 1922, *Farmhouse* was brought from Montroig in the form of a rough sketch and was finished in Paris with the love and devotion of an act of faith. Miró brought some actual blades of grass from Spain so that he could reproduce all their subtle elegance, all their sharp and extenuated beauty, and have the world of Catalonia on canvas in his cold and orderly studio in Paris.

Farmhouse was the great canvas which flapped and billowed in the open taxi that Hemingway rode in when he succeeded in becoming its legitimate owner. It took him by storm, and he bought it at the cost of enormous sacrifices, finally having to make a collection among all his friends in Paris simply to reach the price asked by the painter, who had put his highest price

Fig. 14

Pl. 2

Fig. 12, Pl. 6

Fig. 15

Fig. 16

Fig. 17

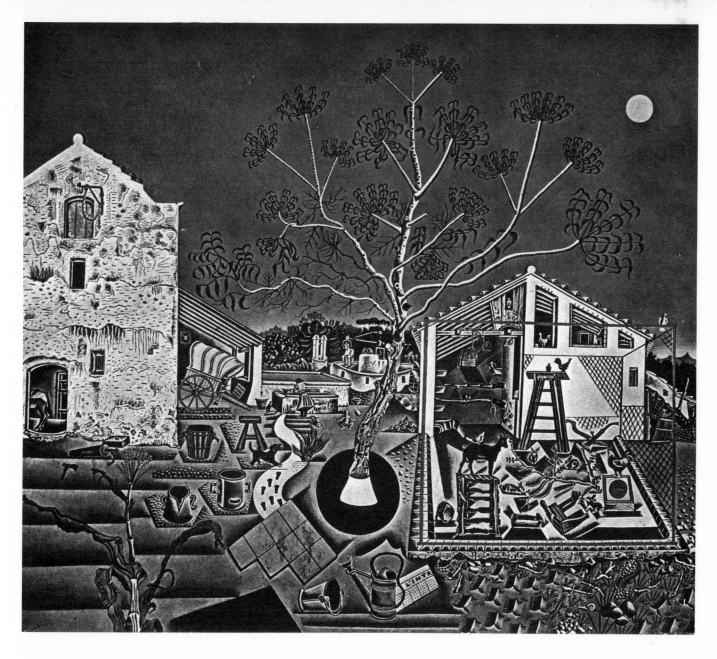

ever on it in the hope that he would not have to sell it.

In 1921 Miró had held his first Paris exhibition at the La Licorne Gallery. It had been a total failure, although Maurice Raynal's presentation of Miró's work gave a glimpse of the painter's courageous innovations, being shown for the first time to the Parisian public, which has always been hard to please. 'Miró is very audacious, but his audacity never provokes, though it is sometimes quite reckless'. Miró had reached a stage where he could look upon reality with detachment and could project it into a dream-like atmosphere. In *Farmhouse*, reality is caught with metaphysical clarity, its constituent parts broken down and enumerated in a way which suggests an inventory. Here the artist, is in fact, making an inventory of his entire world: the white-washed walls of the farmhouse–a Mediterranean white in which every crack, every blade of grass and every line is deeply etched; the scattered country objects: the watering-can, bucket, tub, ladder and cart, next to green leaves of maize growing at regular intervals in the brown soil; the earth of the fields, furrowed and geometricised. Here, too, are the machines with their hidden cogs and gears, like a clock movement which symbolises the regularity of nature. This lovingly composed mosaic is surmounted by the unmarked sky of a Persian miniature or a dream of the Orient. The giant eucalyptus tree, born as if by magic from its black circle of earth, stretches its branches and spreads the fan of its leaves like a peacock's tail against the sky, tickling it and the sun with the feathers of its leaves. This picture expresses the poetry of things seen as though through a child's eye, and the elegance of

17. *Farmhouse*
1921–2, oil on canvas
52 × 57⅞ in (132 × 147 cm)
Hemingway collection,
Havana

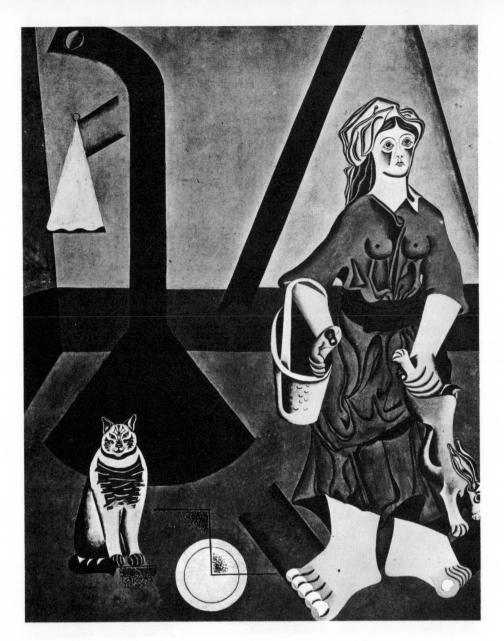

18. *The Farmer's Wife*
1922–3, oil on canvas
$31\frac{7}{8} \times 25\frac{5}{8}$ in (81 × 65 cm)
Marcel Duchamp collection,
New York

the society which produced it. It represented his farewell to Spain and to his first self.

Now he joined the fray. The passage from the metaphorical but realistic representation of his subject to the pure symbolism which he was later to employ was gradual; he was not able to make the progression suddenly and all at once. *The Farmer's Wife,* painted only a short time after *Farmhouse,* smacked more of Paris than of Montroig and more of his studio than of the Catalonian sun. Already Miró was beginning to learn the art of alchemy and starting to systematise his selection of reality. He took as his model a figurine from a set depicting the birth of Christ in the manger, and *The Farmer's Wife* retains some of the plaster-cast immobility of this figurine, her enormous Picassoesque feet symbolising her solid attachment to the earth, for she is the very incarnation of firmness and solidity. The objects around her, the stove, the duster and the basket are geometric forms fitted into the overall geometry of the composition. The rabbit, brother of the one we have already seen basking on the table in the still-life described earlier, and the big cat on the left are the sole remaining examples of realism pushed to its most detailed extremes, but they look as if they have been cut out of another world and inserted into the picture. *Ploughed Earth, Montroig* of 1923–4 signalled his final and complete rejection of these standards in favour of a hard-won language of his own. His attitude to reality changed entirely, and instead of trying to force his way inside reality to capture its every detail, he let himself be infused by it and by the sensations and state of mind it aroused in him. If one looks closely one can see that the elements are the same as those in

Fig. 18

Fig. 19

Farmhouse, but freed from the constraint of realistic dimension and proportion. The house, threshing floor, cock, rabbit, dog, plough and snail have risen from the dreams of the subconscious, and might recall in a different context, in another age, the puppets and armours in the great battles painted by Paolo Uccello, in which the jousts, the fallen and the lances combine to create a metaphysical atmosphere. These, too, were precise fragments of a certain reality, seen in different perspective and inserted one beside another as in a collage. The trunk of Miró's stylised pine is swollen by an enormous ear and a watchful eye punctures the thick green mantle of the tree, looking like a person; and it is a person in the same way as the fig with its single leaf or the cactus with its two serrated offshoots rising miraculously from the ground. This is the realism of poetic realism and it has its own dimension—a dimension of the imagination, as real as the measurable dimension of the world around us. This is pure metaphor, complete abandonment to inner fantasy in an endeavour to return to the most elemental form of expression that of primitive man and that of children, in an attempt to rediscover the lost secret of primordial painting and to forget the commonplaces and rules of an external world for ever bound by an established order from which it is seemingly unable to set itself free. Out of this stemmed Miró's subjectivism which later developed towards that of Chagall, who had repudiated the rules of realistic representation as far back as 1910, at the same time as Klee, whom Miró knew around 1924 during this period of transition. He could not, however, cite Chagall and Klee alone as sources of his new scheme of things. It was familiarity with the work of the poets which above all prompted the change. In a sonnet beginning 'La nature est un temple où de vivants piliers', Baudelaire described the world as an infinity of interrelated symbols. Other poetic influences included Nerval's animism and Rimbaud's poetry, in which the universe also spoke through symbols. For these poets, then, as for Miró, everything was alive; all things must be made to set themselves free from the positions where man had for centuries held them pinned down in the per-

19. *Ploughed Earth, Montroig*
1923–4, oil on canvas
26 × 37 in (66 × 94 cm)
Clifford collection, Radnor, U.S.A.

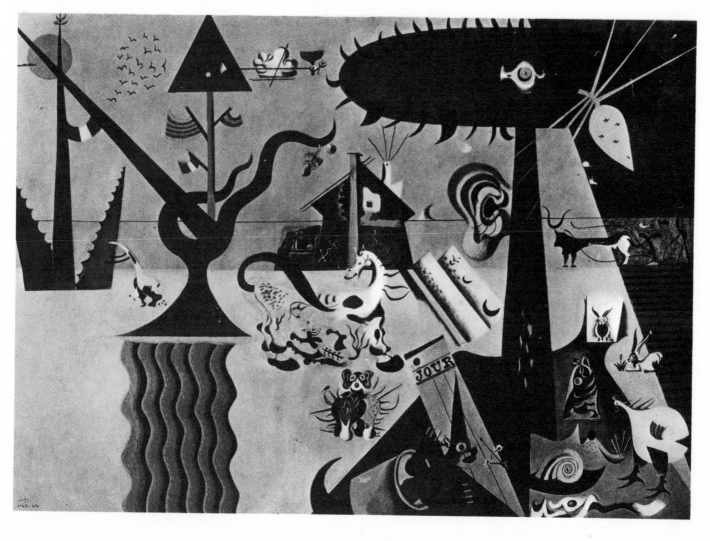

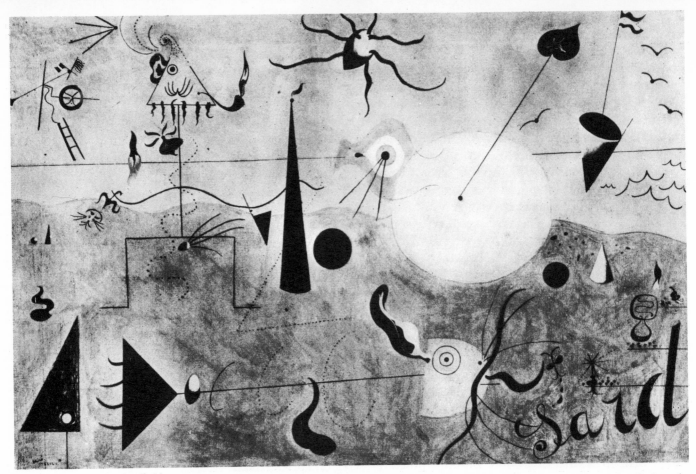

20. *Catalonian Landscape (The Hunter)*
1923–4, oil on canvas
25⅝ × 39⅜ in (65 × 100 cm)
Museum of Modern Art,
New York

manent mathematical plan he had thought up for them. 'If I think of a beetle or a snail, it can be as big as a house, and my imagination can amplify a toy so that it symbolises the entire human race. Thus, if I want to depict these things as I imagine them and feel them inside me, I will allow my instinct to guide my hand on the canvas. I will place them in an enlarged dimension where the sky is yellow with light and the ground dazzling white, where blackened furrows trace delicate patterns.'

'I am able to escape into nature in her absolute state and my landscapes have nothing to do with external reality. I always work indoors: nature for me is only a point of reference,' wrote Miró in a letter about this time. In another he said, 'Am working flat out and with great enthusiasm. Monstrous animals and angelic animals. Trees with ears and eyes, a peasant in his Catalan beret holding a shotgun and smoking his pipe. All my painting problems resolved. Expressing all the golden flashes of the mind.' At last he had entered the new world of 'golden flashes'. He was painting *Paraffin Lamp,* *Portrait of Madame K., The Family, Head of a Catalan Peasant, Motherhood* and *Catalonian Landscape.* He was about to produce the famous *Harlequin's Carnival,* his most consummate expression of his new world, in the same way as *Farmhouse* had been the greatest sublimation of the old.

Fig. 21
Fig. 20

The power of the imagination

In the series known as *Grey Backgrounds* which preceded *Harlequin's Carnival,* he was clearly investigating the ideas of the *avant-garde,* prominently those of the new and flourishing Dada group, headed by Picabia and, naturally, those of De Chirico, father of Surrealism. But these were only elements to be incorporated in his new alphabet of symbols and abbreviations, its characters acquired laboriously and with increasingly drastic simplifications. In escaping into his own and entirely new world, he sometimes fell back on the world of children and child-like metaphor; a horse became a merry-go-round horse or a rocking-horse. Or else he relied on dream-world images, as in his stupendous *Portrait of Madame K.,* a poetic and metaphysical description of woman, a homage to woman, in which he scorned any interpretation of reality in terms of childish playthings. The synthesis was achieved with but few key images—the heart, one breast in profile, one facing us, a fiery triangle

Fig. 21

to indicate the sex, two lines diverging from the triangle for the open legs, and, at the top of the pole which represents the spine, a mannequin's head on which a few serpentine strands of hair are stuck, like a halo. The mystery of woman and her attributes becomes a slender arabesque, inserted within the dominant structure of a large rhomboid, smaller rhomboids interlocking within the confines of the frame.

The sense of dimension, which seems freer, is in fact subject to and dominated by iron laws which are determined according to the requirements of the individual picture. The outside world is a reality to which every artist must in some way be subordinate, being free only to interpret it as he wishes. Henceforth, for Miró, only his own world existed, or rather the world of each of his paintings, in which signs and symbols balance and correspond in a perfect equilibrium which cannot be upset by any change or by the insertion of any extraneous element.

Let us take *Motherhood* as an example. A solid black triangle represents woman's centre of gravity, like the pendulum of a clock. This is suspended by a tiny thread from the familiar symbol of the mannequin's head, coloured dead black and with its ring of serpentine hair. The thread is attached to another weight, an enormous moon-like breast with the suckling female hanging on it, balanced at the other end by a sun-shaped breast which carries the suckling male suspended like an ear-ring. The intention is to sum up the world of a child in the tenacious clinging and defenceless fragility of these spider-like beings, and in the depiction only of woman's sexual attributes. The whole concept is viewed with the minute vision of a tiny child, fragile and alone, hungry for growth; thus the big black triangle gives the idea of the womb, the instinct of security of motherhood, a mysterious form, matrix of the world. In this diagonal composition, whose axes swing on a pivot which is the earth, a perfect balance is achieved, that of a solid in motion, in suspension, such as might be suggested by a most profound and dramatic idea of motherhood.

Pl. 7

The Olympus of his new mythology and the synthesis of his two experiments was reached in *Harlequin's Carnival,* on which he worked throughout the winter of 1924–5. With the delicate drawing which was his custom he suspended his object-symbols in mid-air, where they hover in a crowded and ill-defined space which extends to infinity. Like the 'parole in liberta' of the Futurists, these symbols are distributed around the vast hypothetical room of his imagination, which Miró depicts as a humorous nightmare. As in his imagination, he sees and records all without awareness of dimensions and distances and without any logical coherence, but according to his own logic and with rhythmic interrelationships. It is a vast vaudeville made up of curious objects, strange deformed beings, little monsters appearing out of cubes, winding themselves around poles, and hovering in mid-air, precariously suspended on thin strings. It is a spectacle for adult children in which the fantastic playthings stand for more ominous counterparts, their acrobatics signifying more dangerous exploits on other trapezes in the real world, with or without safety nets. Miró, who could not bear the harshness and rigidity of reality, and who had tried to show the harshness of the Catalonian countryside as a reflection of his all-embracing internal bitterness, had finally escaped into the realms of symbolism and metaphysics. His story reveals itself in this seemingly humorous picture which bewitches and hypnotises, giving the vague unease that one feels in front of the fifteenth-century painting of Hieronymus Bosch. It seems probable, if not certain, that Miró had looked at and admired some of the work of Bosch in the Louvre, more intrigued by the malformed and diabolical beings created by this great Dutch painter than by the supine nudes of Titian or Rubens. Just as the frescoes of Catalonia had helped him towards his first synthesis of 'Romanesque Cubism' and just as prehistoric cave-paintings remained throughout his career the prototypes of the magic he hid in a motif, so the troubled creatures and the infinite surrealist world of the mysterious Bosch,

Harlequin's Carnival
Pl. 8–9

21. *Portrait of Madame K.*
1924, oil and charcoal on canvas
45¼ × 35⅛ in (115 × 89 cm)
René Gaffé collection,
Cagnes-sur-mer

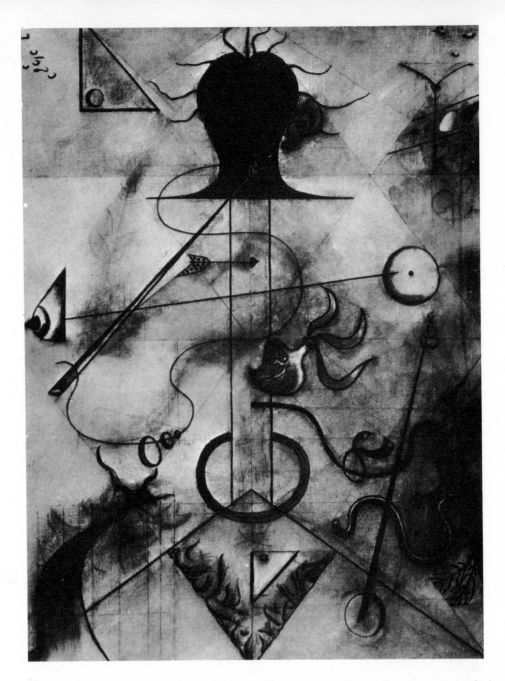

with its troubled creatures and weird and monstrous inventions, reappear in Miró's kaleidoscope, though more benign in their Mediterranean form. They are infused with new and vibrant colours, with an entirely theatrical sense of the macabre. No longer imbued with their malevolent and dismal Northern character, these curious figures and insects are no longer the sick and malignant creations of a medieval Flemish subconscious.

We can see a trace of *Harlequin's Carnival,* indeed almost a suggestion of how Miró might have begun it, in a piece written by the poet, Robert Desnos, who was moved to record the times in rue Blomet and Miró's studio: 'One wall was entirely covered by immense and scarcely touched canvases on which the red Catalan beret was to be seen more often than anything else. It was a fine day; the sun lent the enchantment of solitude and the country to the miserable overgrown courtyard. In one corner of the room stood a table littered with toys from the Balearics, little gnomes and strange plaster animals varnished in brilliant colours. These tiny creatures looked as if they had stepped straight off the canvas of *Farmhouse.*' Off the canvas of *Carnival,* more probably. It seems safe to identify the table on the right of the picture with the one Desnos saw covered with coloured toys from the Balearics, and the abstract vacuum in which the enchanted toys hover might be said to be the vacuum of the studio where 'scarcely touched canvases' hung.

Starting thus from an abstract negation of reality which brought him

closer to his Dadaist friends, Miró had succeeded, through his imagination, in creating a second reality which was equally physical and terrestrial, even although outside physical reality. In place of objects, things or portraits fixed within a scheme and immobilised in the classical style, Miró had found a way of inventing a situation where objects, things and portraits were free from conventions, ties, preconceptions, and were not subject to moral law or social convention. With his rich imagination he dissected his subjects, and seizing the essence of them, presented them in summary in an arresting and fanciful way which immediately gets across, piercing the conscious world and touching the most intimate chords of our psyche.

The triumphant discovery of the subconscious had only recently been made. Freud and his theories affected not only science and philosophy, but also took hold of the imagination of writers and poets, who strove to describe their innermost sensations and to explain hidden complexes, their efforts till now restricted to the narrow precincts of the conscious mind. The excitement generated by the discovery of a new language and the doors it opened spurred Miró on to a period of frenzied productivity during and after *Harlequin's Carnival* which showed his impatience to express himself immediately and in a multiplicity of ways along the new lines he had taken. His fertile imagination, his desire to perfect his pictorial vocabulary of ciphers, his conception of emotions and the nature of objects, and his use of music and dance rhythms to compose his pictures were all furthered by his continuous contact with music and the dance. Placed as he was in a circle of friends and an atmosphere which were both ideal for any form of pursuit, he had no trouble in taking a keen and active interest in shows and concerts, which he went to regularly. Just as poets and poetry, were a fundamental source of enrichment for his world and a help in liberating his own poetry, so music and dance rhythms enlivened his work, suggesting cadences and phrasing, symbols and gestures, emotional overtones and the art of innuendo.

In the early days of his search for his own language, his true means of expression, his paintings had been shaped by the violence of his home landscapes, the volcanic force of nature, an openly acknowledged joyousness in the sun, the infinite smallness and fragility of a blade of grass, and the infinite greatness of the laws which govern and bind man and rule the universe. Now that he had found his new form of expression, the moral consciousness of his eye dominated and governed all his paintings, his ear listened for the sounds of apparently inanimate objects and his imagination soared until it became one with the harmony of the universe, like a shining star in a child's drawing. This moral consciousness was later to identify itself with the monsters of his Monster period, around the tragic years of 1937–8, when even Picasso was to strike a strident and livid chord in the lacerated and splintered music of *Guernica*. The themes of his paintings from 1924–36 or '37 oscillate between ingenuously optimistic child-like metaphor and the mysterious, half-earnest sexual or sensual metaphor, hovering between the triumph of life and the annihilation of death, between the two lying sex, the meeting-point and both the beginning and end of everything.

In *Head of a Catalan Peasant,* a subject dear to Miró, he again shows the mythological interpretation typical of his new form of expression, with mechanical precision and technical refinement of the clockmaker's art. The composition is made up of a set-square, surmounted by a beret and bearing whiskers and a pipe. In its analytic simplification this painting includes a flower in the foreground, a beetle watching us curiously, a moon with a wake of flames, like a jellyfish swimming across the aquarium of the sky, or, in a more modern context, missiles knifing through incorruptibly blue abysses of space. *Dialogue of Insects* once again reflects Miró's view-point and conception of the world; in *Head of a Catalan Peasant* the human figure loses itself in abstract geometrical interpretation, being symbolised in diagrammatic form, while the animals, the moon and the flowers remain more clearly visible. In *Dialogue of Insects,* the animals take the upper hand, sole

Surrealism: the subconscious and the real

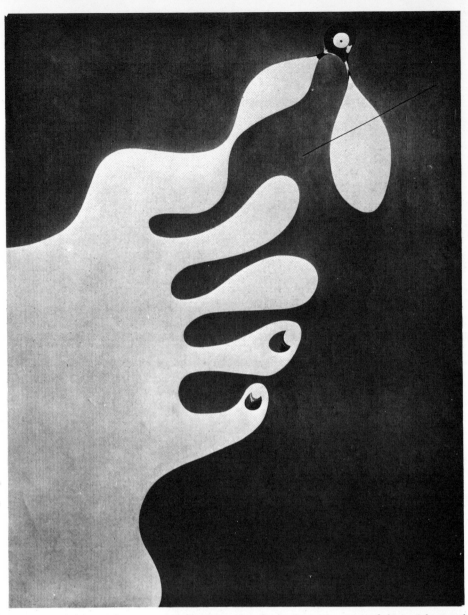

patrons of this arid, sparse land where the fly is the prisoner of the spider and each animal has the same importance as the man in the first picture. In a letter to Rafols, Miró wrote that little flowers and silent insects were more important to him than the great spectacles of nature. In these words lies the revelation of the Miró who, attentive to these tiny things, selected them from the vast repertoire of *Farmhouse* and depicted them in so many other paintings in answer to the response that every small animal or leaf could arouse in him.

However, in paintings like *Landscape,* the figures, symbols, animals and objects which thronged the noisy and phantasmagorical scene of *Carnival* seem to dissolve. This was the high-point of the influence of Surrealism. In 1924, Breton had published the First Manifesto of the Movement in which he stated 'to enslave the imagination, even if in some way what is vulgarly called happiness fills you, means to subordinate the self to all the supreme justice which is found in the deepest soul'. Earlier he had said: 'I believe in the possibility that, in the future, dream and reality, apparently such contradictory states, will combine in one kind of absolute realism, Surrealism.' Miró moved deliberately and happily, master of himself, into the fullness of his dreams. He dived into the maze of the subconscious.

All the Surrealists, headed by Breton, were very pleased with their precious recluse. They published reproductions of his pictures and organised a fabulous exhibition of his canvases at the Galleries Pierre in June 1925, which was enormously and universally successful and naturally gave birth to a scandal. A poet, Benjamin Péret, asked Miró to provide illustrations to accompany the text of his *Cheveux dans les Yeux*. Miró began to be the man of the moment; he was present at his exhibition, as always irreproachably

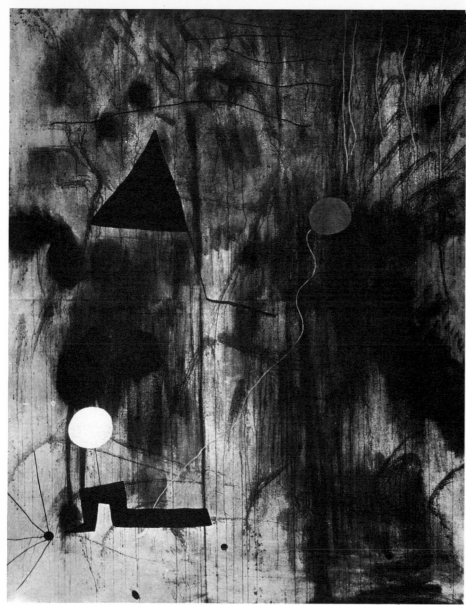

23. *Birth of the World*
1925, oil on canvas
$96\frac{1}{2} \times 76\frac{3}{4}$ in (245×195 cm)
René Gaffé collection,
Cagnes-sur-mer

dressed in gaiters and dark clothes in the old Spanish provincial style, which he had not adapted to suit the fashionable bohemian tastes of Montmartre Montparnasse. He danced rakish tangos with beautiful women often taller than himself and was occasionally to be seen at the Café Cyrano, in the Place Blanche, where the Surrealists held their council; but this was a mere outward appearance which he affected only for a short while. His 'inner voices' were working within him and his imagination was filled with the impalpable essence of dreams, wandering and fermenting in the new dimension which sheltered and encircled them; a sort of vacuum which was a central characteristic of all his paintings of these years.

The paintings produced between 1925 and 1926 were all born under the sign of this reconquered dimension, within which coloured spectres drag their long tails like shooting stars; suns slide across space like animated phantasms; where a word or even a syllable, written in huge letters and following undulating curves against the background, no longer has the allusive significance of synthesis and suggestion encapsuled in the rigid geometry of Cubist or Futurist compositions, but unreels the letters one by one for sheer pleasure and beauty, like the white trail of a jet tracing supernatural signs in the sky. The paintings are woven dreams and their titles are lines of poetry or are composed as the perfect expression of the colours, atmosphere and state of mind of the picture, dictated, as in instinctive writing, by the subconscious.

Man throwing a Stone at a Bird, Hand catching a Bird, Horse on the Sea-shore, On the Banks of the River of Love, Landscape with Cock, Dog barking at the Moon–Miró himself said that to paint a picture one only needs to think of a

Pls. 10 to 12

Fig. 22
Pl. 13

bit of poetry or a harmonious phrase and repeat it to oneself day in and day out, listening to the music in it and finally entering into the music and losing the real sense of the words.

Thus the picture paints itself—a sort of spontaneous germination. It is this 'spontaneous germination' which distinguishes Miró's painting from the rigid Freudian automatism that Breton had preached ('the eye exists in a wild state') and that his poet and intellectual friends now broadcast, at least until Eluard and Artaud rang the changes. Miró was not an automaton, in that his work was not reduced to a system and was not bound artificially to any mechanical methods or techniques. Miró's hand obeyed internal promptings so that a symbol painted on a canvas by him is real and is not part of an unbreakable code. If one can join in the rhythm and state of mind he felt, one joins in the music too.

From representation by means of ideograms, perhaps a shade studied and cold, he passed from being an initiate in the new régime to depict evolutions in the development of dreams, drawing directly on to the canvas from his subconscious, the canvas becoming the scene of a daydream, the empty stage awaiting the fantastic ballet of the formless figures which flitted through his imagination. The resulting pictures were sincere, rich in material and firm in their execution; while at the same time, and oddly anachronistically, he continued to paint his usual Catalonian landscapes, which differed only slightly from earlier ones, during his summers at Montroig. Clearly he was still attached to the style and subject-matter of his earlier period.

The paintings of dreams

Miró's work in Paris was ever more intense and obsessive, almost hallucinatory, as a result of the hunger gnawing at his stomach and the exhaustion draining his strength. His bohemian friends were visibly excited by the poses and posturing of a new and spectacular form of anarchy influenced by the poetry of Novalis, Lautréamont, and Rimbaud. Miró, however, never abandoned himself to external or spectacular fashions. Cut off because of his inner reserve and his unbending Spanish character, he instead let his imagination roam free on his canvas or in the rough preparatory drawings on his sketch-pad, where some details of reality recur with obsessive insistence. Like someone who looks so hard at a thing that he sees nothing, he reconstructs the thing in isolated detail, losing the impact of reality but afterwards with closed eyes all the original stupor and enchantment returns in an almost mystical ecstasy. Miró communicates this particular kind of mysticism in all his most personal and genuine compositions, even if he seems to scoff at it or takes refuge in the grotesque or the ludicrous; it is the indestructible mysticism of the Spanish which appears in many different guises, as it does in Picasso's work.

Pl. 12
Fig. 23

His paintings of 1926–7 were all under the influence of dreams, in an oneiric atmosphere. From *Painting* of 1925, a bare sky swarming with phantasms in gestation, we pass to *Birth of the World* described by René Gaffé, who owns it, and who was one of Miró's first admirers, as 'an aerial ocean of seething, crashing grey and black waves, made turgid by a few handfuls of mud thrown in . . . on the left a black triangle, a giant enigma, and lower down, the abstract barrier protecting the secret and the mystery. But a white circle, the earth, and a red circle, the sun, rise, like balloons parted from their moorings, towards the zenith.' It was to be more than forty years before man could see the heavens and the earth through the porthole of a space ship, yet none of the fantastic photographs with their explosive colours taken through a porthole in vertiginous flight through space, and even less any of the paintings in which Yuri Gagarin, the Russian astronaut and painter, tried to express the extraordinary images of constellations and planets seen from space—none of this evidence of phantasmagoric reality will ever be any more real than the evidence of Miró's dreams, which exorcise the mysteries of the skies and the stars in an almost miraculous way. The most incredible shapes flit through the clouds and across the sky of this apparently empty world; the animated words of *Le Corps de ma Brune,* his pictorial

poem; the recurring circus-horses, classical yet child-like, in the stupendous series devoted to them; or characters like that of *Portrait* of 1927, suspended in mid-air like an immense kite, its shape a grotesque caricature, riding through space along its diagonal. In the same way *Painting* of 1925, which features an enormous caricature, looks as though it was formed in the sky by casual passing clouds or by a meteorite – one of those bizarre and monstrous heads which any errant imagination discovers in the sky among the billows and feathers of cloud; just as we can see animals and figures in the spreading patches of damp on an old wall, as Leonardo did. The beings who awake and find themselves hanging in this great emptiness are no doubt amazed at their own existence, like *The Brothers, The Personage,* or *The Head* – a sort of lion's, tiger's or large cat's head, bearded and conceivably only a cloud.

The colours on his palette at this time were varied too, as adaptable as the lines of his drawings or the outlines of his phantasms; cadmium yellow, lacquer di Garanza, Prussian blue, cobalt blue, and opaque chalky whites. The colours are clear and consistent, terse daubs within a line which defines rather than contains them, sometimes just roughed in with visible strokes, the leaven still in the pigment. He paints wide horizons, the magic lines of the horizons around which he had constructed his first landscapes and which remain part of his new language. With the horizons and plants of his earlier paintings are combined fantastic animals and beings all united in that sense of space and magic which is the basis of Miró's poetry. In *Man throwing a stone at a Bird* a white figure is making a wide gesture, outlined against the coloured head of a bird suspended on a blade of grass. In the foreground lies a

Fig. 24

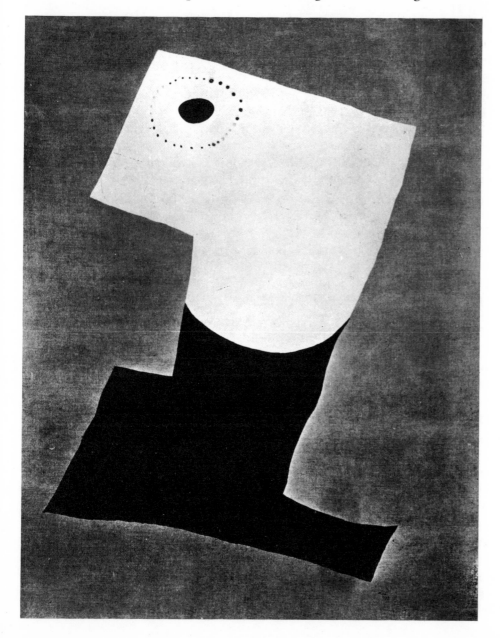

24. *Portrait*
1927, oil on canvas
$57\frac{1}{2} \times 44\frac{7}{8}$ in (146×114 cm)
Private collection,
New York

yellow shore on an inky sea, beneath a green sky, moiré like silk.

Pl. 13 In *Dog barking at the Moon* a dark slate sky hangs over the brown undulating land which occupies more than a third of the picture, with a moon rent in a hole at the top like a tear or a puncture, hanging in space like a cuttlefish bone polished by the years, while a slender coloured ladder reaches towards the sky like gasping desire. The dog, stuck on the ground, barks at the vast infinity of the warm Mediterranean night. In Miró's painting the ladder has always been a symbol of conquest and of escape (there is actually a famous

Fig. 29 painting called *Ladder of Escape*) and it retains this role right up to his latest paintings.

One of the most significant paintings of this period, *Nude* of 1926, hints at a humorous parody of feminine nakedness, putting sexual emotions on the level of the grotesque. Made up of entirely feminine curves, gestures and inflections, this figure has a pear and an orange as breasts, her sex represented by a veined leaf and her hair by a banner. The oval of her face, bright with light, looks like an egg with a transparent skin through which an eye, two concentric circles of red and yellow, looks out amazed. Also at this time came practical contact with the theatre. Together with Ernst, he was asked to design the sets for a production of *Romeo and Juliet* by Diaghilev's Russian Ballet. These contrasted strongly with the work of purist Surrealists. They were imbued with Miró's own poetry, child-like symbolism and sane Catalan folklore, which he never, even in this period of pure poetic language, abandoned. Among his friends were Paul Eluard, Max Ernst, with whom he worked, and Arp.

The Dutch Interiors Miró's *Dutch Interiors* were born out of his travels in the Netherlands. They were fantastic transformations or re-inventions which resulted from the emotions he had felt in the museums of Amsterdam and The Hague. It is extremely interesting to follow the transposition of the microcosm of sixteenth- and seventeenth-century Dutch painting into Miró's key, just as it is interesting to find traces of Rubens or Titian in a Renoir, or Botticelli in a Modigliani. In Miró's reinterpretation the complex and loaded world of the Flemish seventeenth-century artist, with his accumulation of details patiently assembled in monastic calm, is bitterly but not irreverently criticised. A series of fragmented, contorted and entangled figures is arranged in segments in a syncopated rhythm, contrasting with that of the Flemish original which epitomised the methodical rhythm of bourgeois life. It is not, however, a polemical or scornful critique of that world; it is rather a statement of the distance between that world and his, of the impossibility in the twentieth century of finding those calm, self-possessed and well-balanced people in that comfortable and complacent atmosphere. In Miró's variations on this theme, the strident sounds of our era can be heard, just as they would be if Stravinsky revised Bach's *Variations on a Theme*. The characters in the Miró paintings are deformed caricatures of their Dutch counterparts and only the animals retain the same spirit, the only real point of contact with our century. The whole period up to the collages of 1929 is built around the curves, ellipses and ample deformities of classical traditions and compositions.

Pl. 14 After the *Dutch Interiors,* of which an example, *Dutch Interior No. 2,* is
Pl. 15 illustrated, it was the turn of *Queen Louise of Prussia* or the *Mrs Mills of 1750,* or *The Baker's Wife* (after Raphael, as it states in the sub-title), which is reduced to an enormous pink *décolleté,* a sort of conch shell supporting a lone eye with a menacing look, all perched on top of the black dress as if on the rim of a volcanic crater.

There is one type of person who goes to the Louvre (the museum with a capital 'M') on tiptoe and in a state of religious adoration; and there is another type who, like Miró, wants to see the most famous paintings of our forefathers through new eyes, without the stock phrases and deductive judgements, probably with a wry smile of light and pungent humour; there is yet another type who just gets angry and protests. There was thus, in this choice of a famous model, simply the opportunity for a concise personal

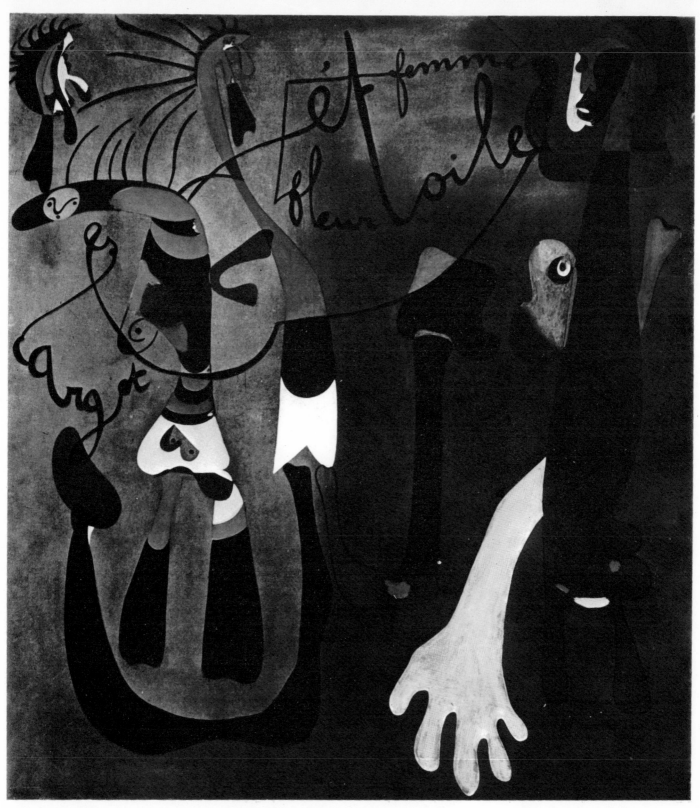

discourse on form – quite without scruple or prejudice, but with a sort of superior indifference. 'Without knowing where he is going,' Breton wrote of him, 'he goes at it quite without involvement of care,' getting ever further inside the unconscious and ever further away from Surrealism, joining in the same quest as Mondrian and Kandinsky, to name the paladins of abstract art.

The stupendous collages of 1929 were heading right this way, and were a criticism of painting itself, 'which has been decaying since the Stone Age,' said Miró. He declared war in an outburst of anti-painting. It was easy to smash the vehicle of other painters, but Miró went further. He suppressed line and colour, and created a new medium, which represented a new concept in painting, a new entity, a challenge and a negation. He finally arrived at a sense of primaeval space, buzzing with hidden existence, as on the day of the Creation, and where figures, planets, and sound-waves hang in mid-air like embryos, capable of becoming anything.

25. *Snail, Woman, Flower, Star*
1934, oil on canvas
$78\frac{3}{4} \times 67\frac{3}{4}$ in (195×172 cm)
Pilar Miró collection,
Palma, Majorca

Pl. 17

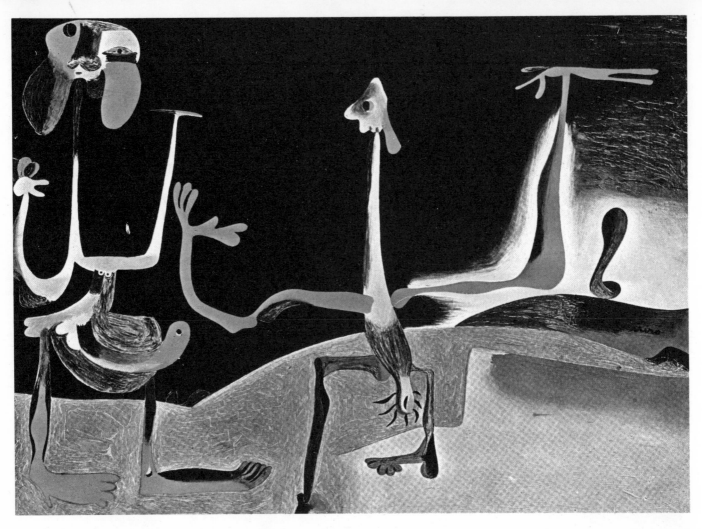

A spot falling in the right place
Pl. 16

26. *Man and Woman in front of a Pile of Excrement*
1936, oil on board,
$12\frac{5}{8} \times 9\frac{7}{8}$ in (32×25 cm)
Pilar Miró collection,
Palma, Majorca

Fig. 25

His *Painting* of 1930 is a good example of this phase of liberation and heretical iconoclasm. In it he expresses desolation and solitude, renouncing even coherent mental organisation and expressing himself in daubs. It resembles a fragment of nature, constricted by the hard and clear-cut outline of a cameo, but floating in the stratosphere. There followed his *Constructions,* made of various objects picked up from the street, the beach, offices or anywhere: bits of wood, bits of rope, cork, shells, nails, a bone polished by time, anything could become one of these pictorial objects. Then, in 1932–3, after a gap which denotes a crisis of some kind, Miró, the painter, really emerged with colours, plastic compositions and free, flexible forms, which he produced after leaving Paris and going back to Barcelona for a time. This fertile and productive period evolved in the attics of the house in which he had been born and produced a series of collages which have assurance and a renewed command of his language. Now that he had recaptured a sense of volume and had rediscovered colour, his titles regained their poetic quality: *Swallows, Love; Snail, Woman, Flower, Star.* Common objects which he had depicted unaltered in earlier compositions were now metamorphosed through contact with the new Miró. He had newspaper cuttings and sales leaflets of these objects which he stuck on a sheet of white paper on the wall of his studio and used as his models. They returned magnified in his paintings, yielding to the artist's fantasy and shaped anew, as with the hair which appears in his beautiful *Homage to Prats* (1933), his great friend from the first heroic days in Barcelona. With the good taste of the man who knows his subject, Miró now played with compositions which now included images taken from picture cards, old scenes of lovers or *femmes fatales,* thrown together with butterflies, snails and beetles drawn from children's books. He surrounded the images with great flowing arabesques which comprise the structure which carries them; wire castles carrying coats of arms or symbols, photographs of a whimsical reality presented with a gentle humorous smile. 'I saw the need to surpass the plastic element by linking it with poetry,' he said by way of

explanation of his line of thought at that time. These were serious games, examples for painters who came after him, a sort of refined *divertissement* in which Miró is quite unsurpassed.

Giacometti, who was a close friend of his at this time, made some observations which pin down exactly Miró's way of composing these marvellous surrealistic montages, perfectly balanced between fantastic exuberance, child-like ingenuousness and firm and measured execution, which only a consummate poetic master could achieve. 'Miró was the very incarnation of freedom. His work was airier, freer, lighter than anything I had seen before. In a sense it was absolutely perfect. Miró could not paint a spot without it falling in the right place. He was such an extraordinary painter that he could put three blots of colour on a canvas and it would be a picture.'

Miró had in fact achieved pure form, as had Brancusi and Arp, though by different means. His airy way with forms, his spontaneously organic and linear drawing now emerged like a sublime arabesque which had found perfect expression. From this fantastic euphoria with its harmonious dreams, he slid insensibly into the cruel period of *Monsters* and *Metamorphoses*,

The Monster Period

27. *Self-portrait*
1937–8, mixed materials on canvas
$57\frac{1}{2} \times 38\frac{1}{4}$ in (146 × 97 cm)
Private collection,
New Canaan, U.S.A.

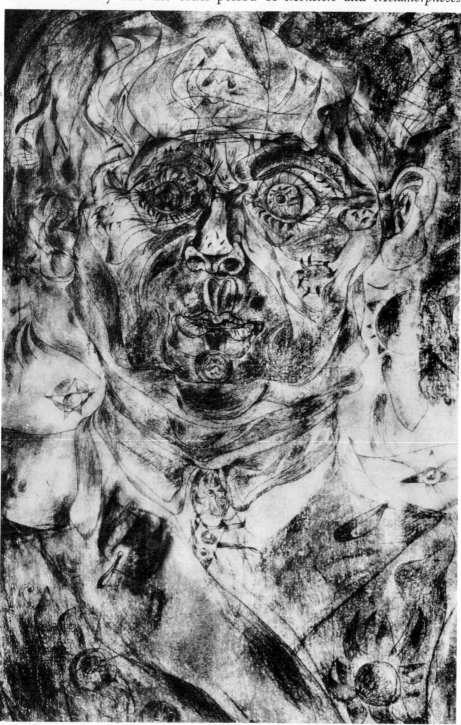

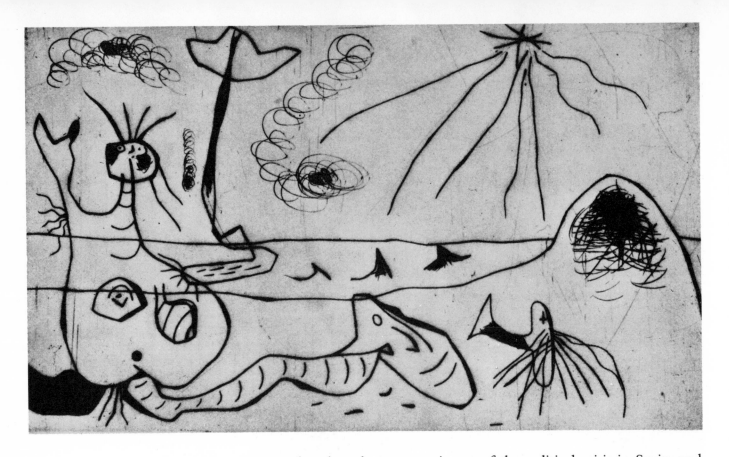

28. *Woman bathing*
1938, dry point
$6\frac{1}{8} \times 11\frac{7}{8}$ in ($15\cdot5 \times 30\cdot2$ cm)
Limited edition of 30 published by
Pierre Lock, Paris,
and Pierre Matisse, New York

Pl. 20

Pl. 21, Fig. 26

Pls. 18, 19

prompted perhaps by a presentiment of the political crisis in Spain, and continuing till 1938 when the situation was resolved. From 1934, like a sensitive instrument which records seismic tremors distant in time and space, and foresees future disasters, Miró betrayed hints of change; like an anemometer measuring changes in the wind, his painting began to give off ominous groans. He went from a state of carefree unconcern to a state of alert, without anything happening to disturb the calm of his bourgeois existence. Now a family man, he had enough money, a happy wife and a daughter. Nevertheless, he felt a foreboding of tragedy around and within himself, a collective tragedy whose symptoms were becoming evident, a sort of sadness showing the emptiness and futility of a world system which was about to be overturned. The cry of laceration, the tragedy of violence, brutal aggression, insane bestiality and unchained animality of the world, which was preparing to tear itself to pieces, all this was communicated in pictures which Miró himself called *Paintings of Salvation.* These are built around enormous stylised figures which seem to be composed of various organs thrown together as if for a macabre masquerade: bones, livers, breasts, teeth like fangs, shapeless monstrosities which take the place of the freshly coloured kites, laughing faces billowing in the clouds and the humorous and grotesque mannequins of earlier periods. These works are even more tragic in that they are a distortion of the earlier fantasy with its dream-like aura which now became tinged with a livid, spectral glow. Everything is caught up in a dreadful suspense; an indefinable stillness and unhealthy silence paralyse the vital spark of existence. In every work in the years following 1934, the year when the first warnings were heard, Miró fathered monsters; the lines of their faces are deformed, their mouths hang open in tragic grimaces which turn into screams, dull groans and eventually an ominous silence. Typical of this period is the painting *Man and Woman,* in which the figures are depicted in front of a pile of excrement, a key picture, which reflects this sad moment in Miró's life and in the life of the whole world. It is the equivalent of the inhuman shriek of *Guernica,* which, in expressing Picasso's unhappiness of the world, reflected particularly the tragedy of Spain as the symbol and embryo of a sickness which was to cover Europe and eventually the world.

These are small paintings on wood, plasterboard or sand-covered card, but they have the tragic grandeur of gigantic compositions and look as

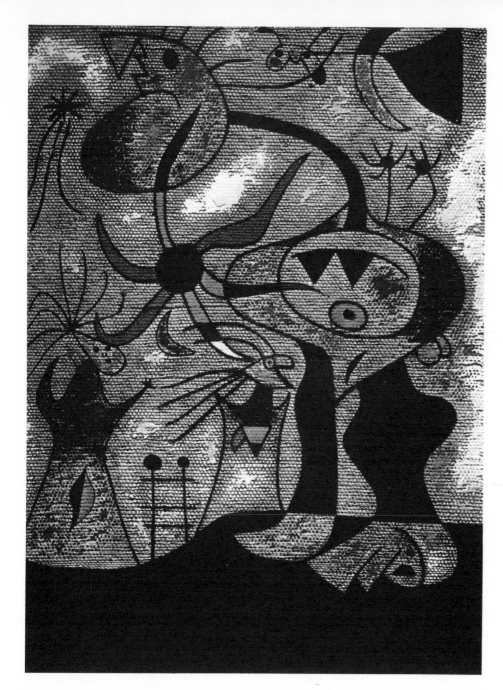

29. *Ladder of Escape*
1939, oil on canvas
$28\frac{3}{4} \times 21\frac{1}{4}$ in (73×54 cm)
Private collection,
Chicago

though they had emerged from the core of the prehistoric world. In a light tinged with madness, their characters drowning in an impalpable fluid, they seem to be a pictorial interpretation of Freudian phobias. And no classical order, as in De Chirico, regulates disquieting muses or swells the sky of motionless Italian squares. Fungi, amorphous beings, swollen shadows and thread-like phantasms throng a metaphysical space, multiplying in their thousands like some horrific nightmare. The tragedy felt by Miró reacting like a sensitive string in the bow of the world, became cosmic, as if paying for and making man pay in expiation of the evil that man was about to do himself. This painful experience and confession were born in the land of his first endeavours, Montroig, beneath the relentless sun, his friend and judge since his youth. Here he had put down his roots, and here he returned to fight his personal war in painting, suffering for Spain, for Europe and for the chaos that was about to descend and which he had prophesied on canvas.

The violence exploded in 1937–38. He went back to still-life compositions, almost in youthful reminiscence, and giving us *Still-Life with Old Shoe,* but like a sick man weakened by fever. The objects decompose before the eyes and under the painter's brush-stroke, as if attacked by acid which corrodes and eats them away. Those objects in his still-lifes of 1922, which were bursting with a desire to live, now retreat, disintegrating behind a sinister

Ladder of Escape

43

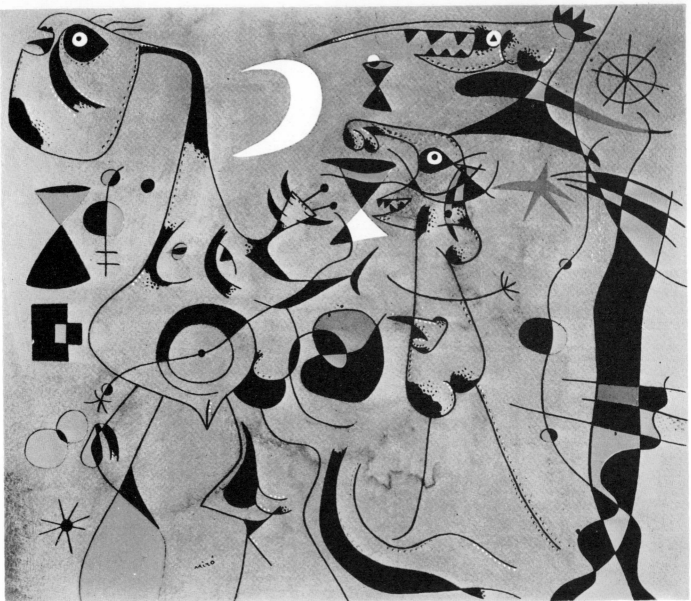

glimmer of light, consumed by the embers of a malignant fire.

Fig. 27 *Self-Portrait* of 1937 reflects Miró's state of mind, depicting himself not as something deformed and monstrous, so much as reduced to a dissected spectre, shown through the geometry and architectural skill which as a young man he had used in his self-portrait of 1919, which comes to pieces like a great card-house. The same impression is conveyed by the *Head of a Woman* of 1938, and in the struggle for freedom already depicted in *Ladder of* Fig. 29 *Escape*. The ladder had come to symbolise the means of escape from the grey slime of the world. But finally, in 1940, an unexpected solution appeared. It came in the guise of music, as Miró himself explained. 'I felt a profound desire to escape. I deliberately withdrew into myself. Night, music and the stars began to play a primary role among the influences on my pictures. Music has always appealed to me and it was at this time that it began to play the part in my life which in the years around 1920 had been played by poetry.' This heralded the beginning of the *Constellations* period.

The parabola of Miró's work, which had led him towards the instinct for death and the ruin of his entire world, so that he was finally seeing monstrous forms in his unconscious, and which was curving gradually downwards into the darkest mysteries of the subconscious, then began miraculously to rise again. Already in December 1939, a picture like *Women and Kites among the Constellations* bore in its title, along with a suggestion of phobias and monsters, the word 'constellation' and the idea, though faint and distant, of stars. This was Miró's star, which later was to triumph over the forces of darkness and burns brightly in so many of his pictures of the last twenty years, being now almost a symbol of Miró's work. It looks like the product of a child's

30. *People in the night guided by the phosphorescent trails of snails* 1940, mixed materials on card 15 × 18⅛ in (38 × 46 cm) Louis Stern collection, New York

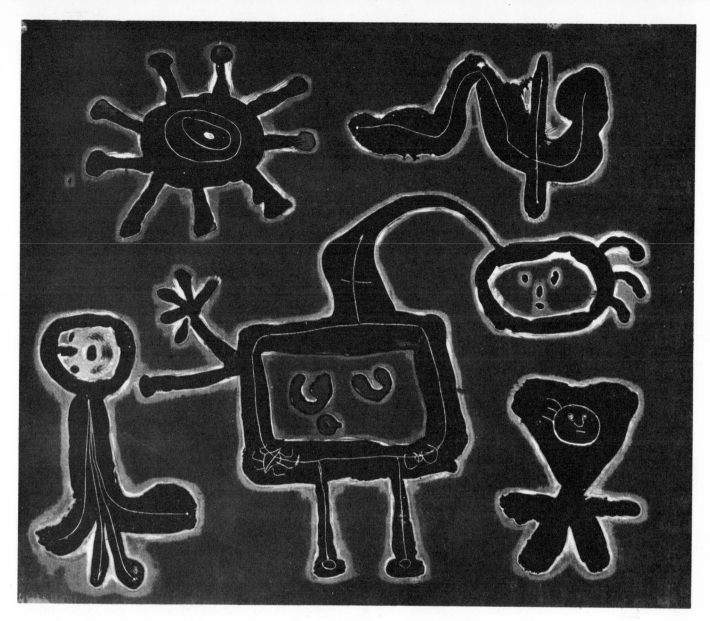

mind, made of silver foil. It is a slender twitching spider, suspended in the
emptiness of the heavens like a Christmas star and with exactly the appear-
ance and symbolic meaning of the tinsel one on the Christmas tree or the
manger.

But it was really 1941 that saw the first of the twenty-three *Constellations*.
Miró had conquered his new world and its firmament laboriously, by climb-
ing up his ladder of escape. He entered the midst of the firmament among the
planets and stars that circle in space, joined by slender threads like a celestial
labyrinth. Spheres and stars of every size hover on the brink of space and
swell the firmament and colour it with fantasy, like children's atlas versions
of the sky at night, with their fabulous representations of the Great Bear and
Little Bear.

A warm, serene music accompanies this gentle rain of drawings swarming
with pure geometrical images, worthy of certain limpid quartets and
symphonies by Mozart. As an example of this series, we show *People in the
night guided by phosphorescent snails' trails,* a surface of transparent azure on Fig. 30
which red geometrical configurations and black filaments weave airy and
undulating arabesques.

Miró's *Constellations* were the first documents to cross the Atlantic after
the war, in 1945, as if bearing the glad news, an exhibition being mounted by
Pierre Matisse in his gallery. Once he had succeeded in depicting nameless
fears and soundless screams in a mathematical conquest of dimension and
geometry, once he had passed this winning-post, Miró did not stop. Having Pls. 24 to 38
found faith, he carried on with renewed confidence towards another goal,
beauty. Under beauty's spell, he continued to paint according to a con-

stantly renewed poetry. Simultaneously with *Constellations,* he painted anti-monstrous compositions, representing Majorca and the Mediterranean sky, as a sort of liberation, and in paintings like *Poetess* and *Woman beside the Lake* he achieved a pure and expressive symbolism and beauty of line.

The Walls of the Sun and of the Moon

He had now reached the stage, in 1949–50, when he rediscovered ceramics. It was his friend, Artigas, his old friend from the time of his arrival in Paris, who, together with Prats, revived his love of the craft and its materials. He now took a different view of the art whose various techniques he had studied at school in Barcelona, seeing in it now a new way forward, a means towards the truth–not just a medium or a technique. One must imagine that one is conjuring with one's material, as Miró said; one must believe in the beauty of the material, be it clay, iron, wood or string, and in the beauty of the colours, in the way they spread over a surface or create a permanent image under the hand of the artist. It was also a return to the earth and to tradition, not as a retreat but as a vital rediscovery and a real source of inspiration.

Pls. 39 to 41

This was also the same direction as was taken quite independently by Picasso. From 1944 onwards, the terracottas which Miró decorated with his magical and cabalistic signs, and eventually shaped with his own hands, poured in great numbers from Artigas's kiln. The big plates, pumpkins and deformed grotesque beings in unlikely and brilliant colours are covered with figured writing recalling Chinese or Egyptian hieroglyphics or even Assyrian and Babylonian characters. *Wall of the Sun,* 1958, and *Wall of the*

Pl. 31–2

Moon, 1960, conceived and executed for the UNESCO Building in Paris, and the other great ceramic panel made for Harvard, also in 1960, mark Miró's return to society and his renewal of faith in it, together with his first contact with America and a wider general recognition of his work. Miró's two great UNESCO panels reflect once again the beauty of the Romanesque wall, combined with the primitive fantasy of the cave-paintings at Altamira, interpreted poetically and with a sense of reverence. The beauty of the wall lies in the fact that the ceramics are composed of various tiles, each bearing a fragment of this beauty like a key to the entire mosaic; but it is still a tile, beautiful in itself, just like any marbled, rough and warm stone in a Romanesque wall. Thus the coloured wall of Babylon, its enamelled lions and warriors divided by the imperceptible squares, is born again. The new, free and fantastic rhythm of the motifs is entirely Miró's creation; entirely his is the elemental and primordial poetry in which the boat, the moon, the sun, the sailor and the stars, in marvellous cohesion, have at once the force and synthesis of the ancient cave-paintings and the nervous quality of the modern fable which screams its colours and silhouettes, painstakingly selected, in a courageous denial of destruction, colourlessness, systems and series; all in all, a precious work of art, like a fresco from the palace at Knossos, transplanted from the Mediterranean sunshine into the mists of Paris and the beehive of a modern architectural structure.

Fig. 31

It should be noted that, although we cannot examine in depth each of Miró's many talents, his graphics are and will remain among the most important of our time. He began this work in his first years in Paris, but it has intensified in recent years, with albums in 1948 and 1960, and with lithographs and woodcuts illustrating books, such as those which were made to accompany Elouard's poems, which are among his more significant works, along with the terracottas, those objects born of earth and fire, which he has most recently produced.

Nor should we be surprised that a painter who has chosen and invented as his own personal language such an original handwriting–a controlled and refined alphabet which has the supreme beauty of barbaric ornamentation, the elegance of Chinese script, and the stylised configuration of ancient hieroglyphics–creates a new picture out of every page on which he draws. Where his graphics are concerned, we should bear in mind those same words that Giacometti used for his painting: 'Miró could not paint a spot without it falling in the right place.'

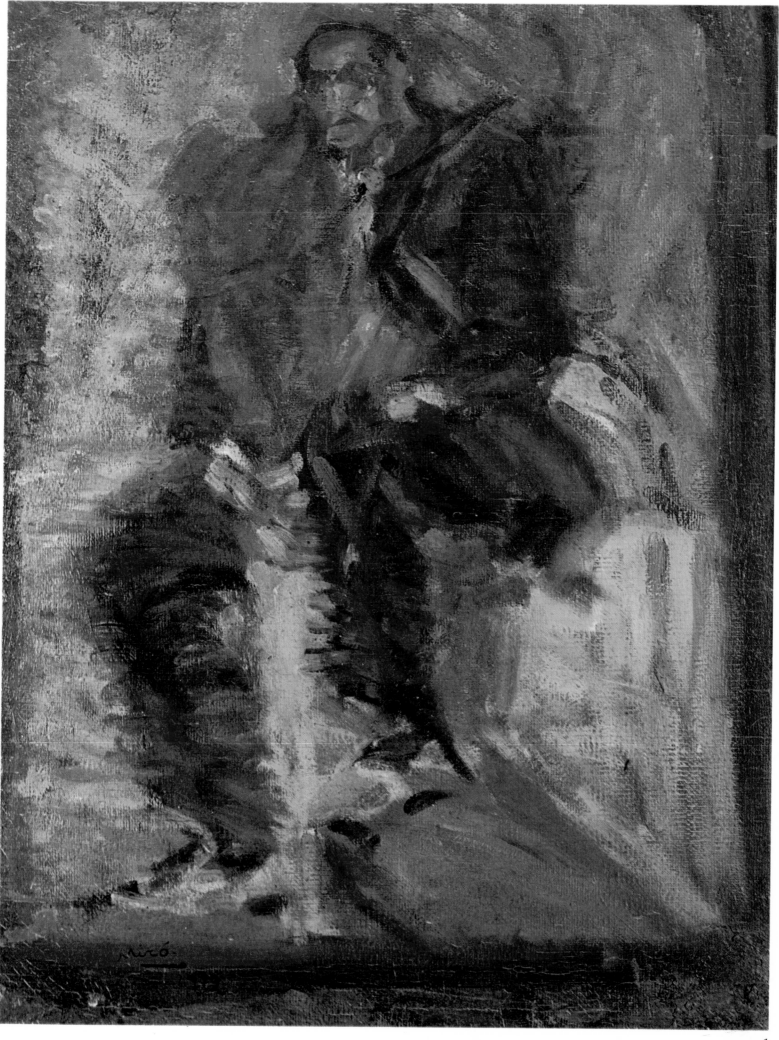

1

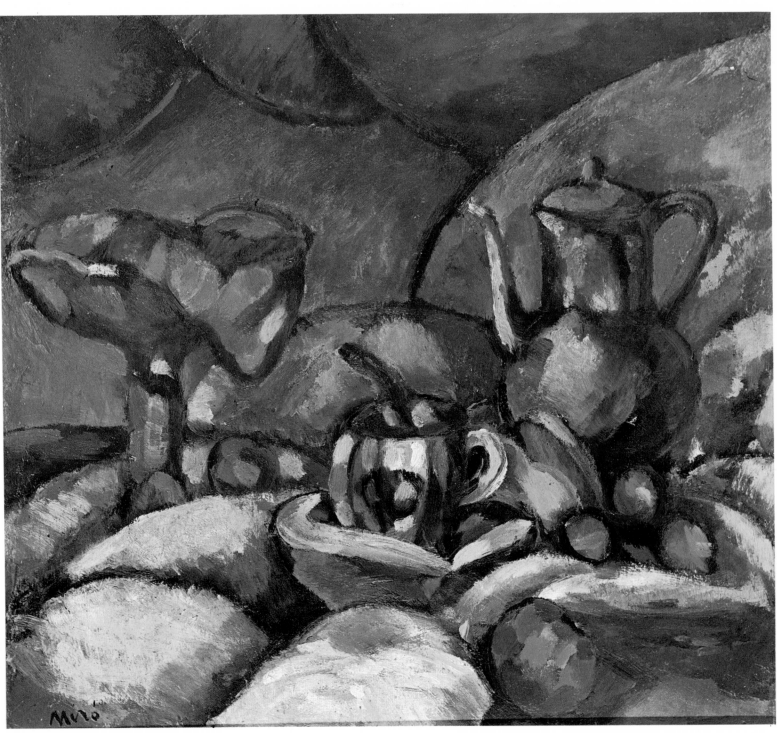

2

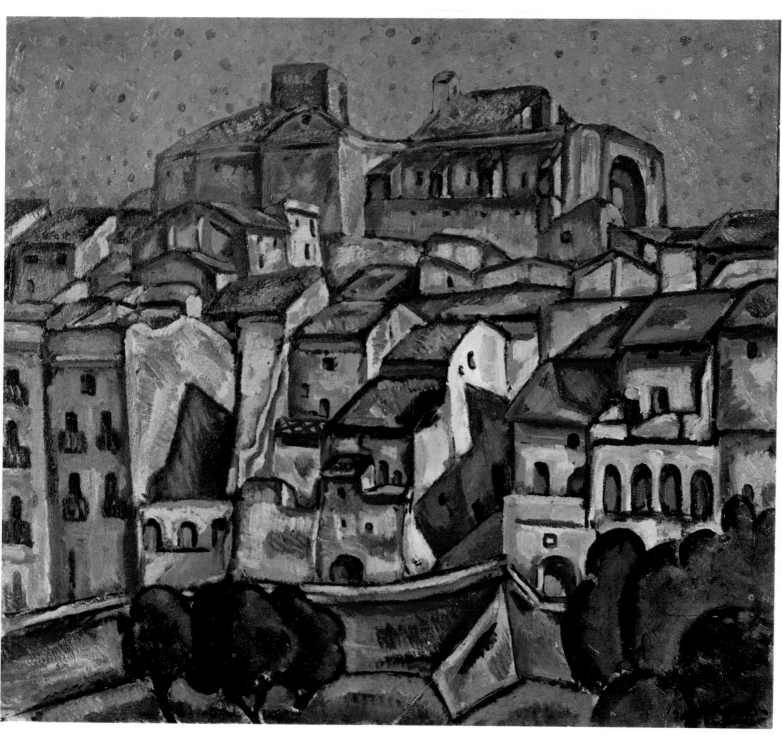

3

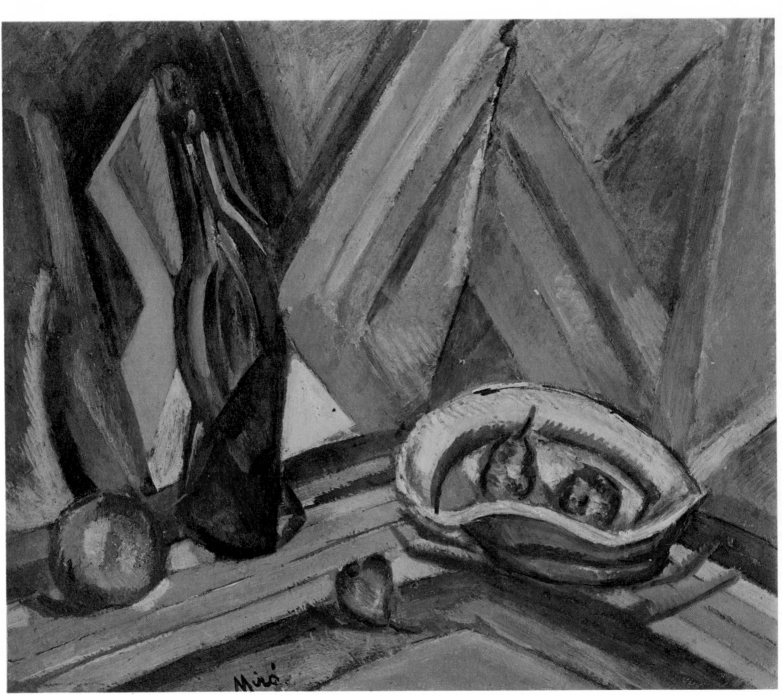

4

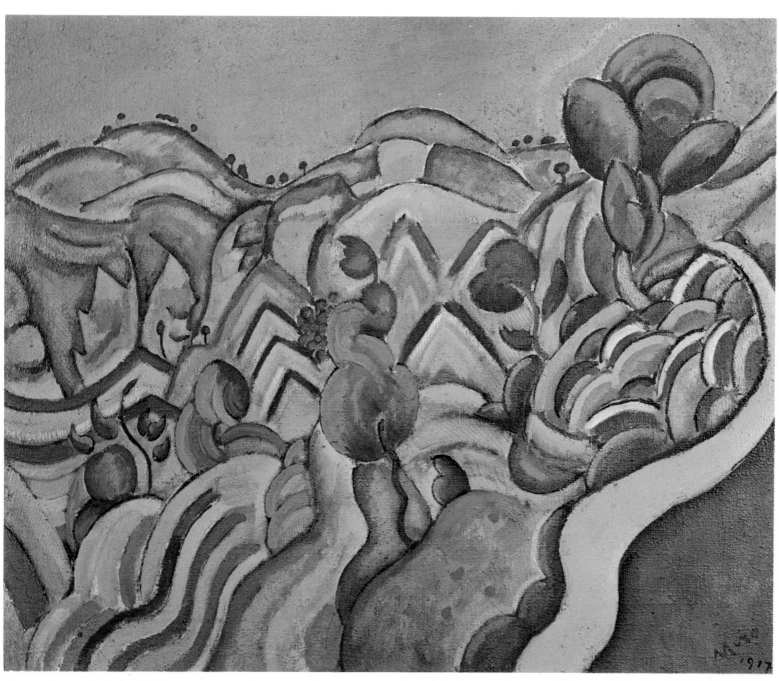

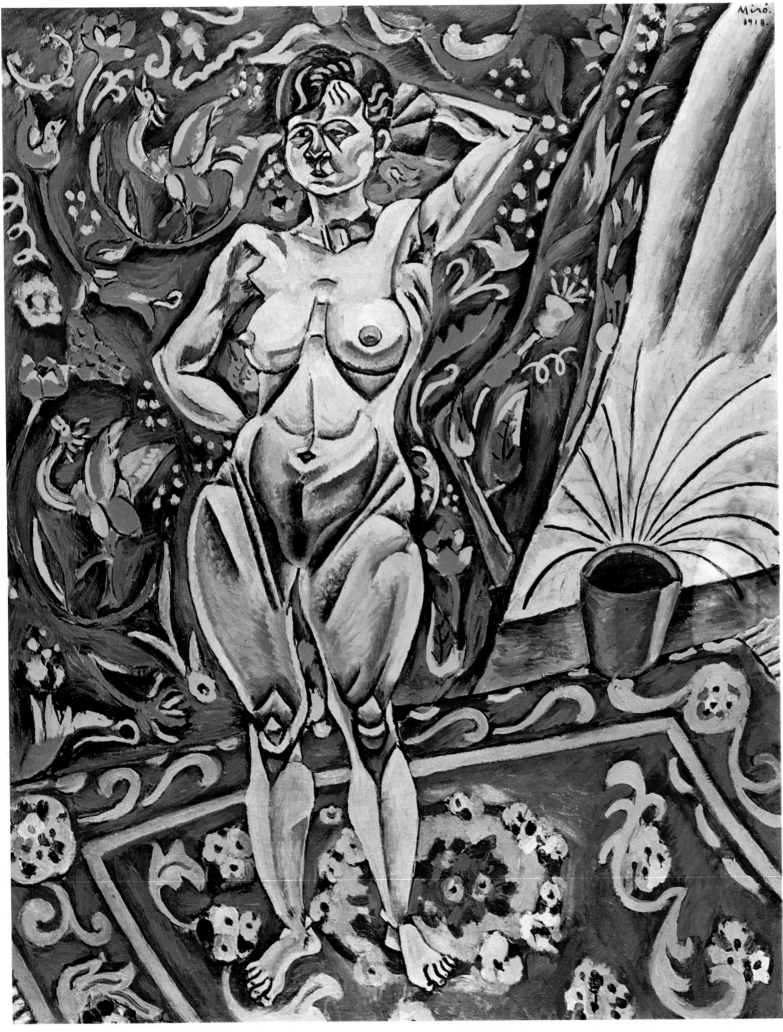

6

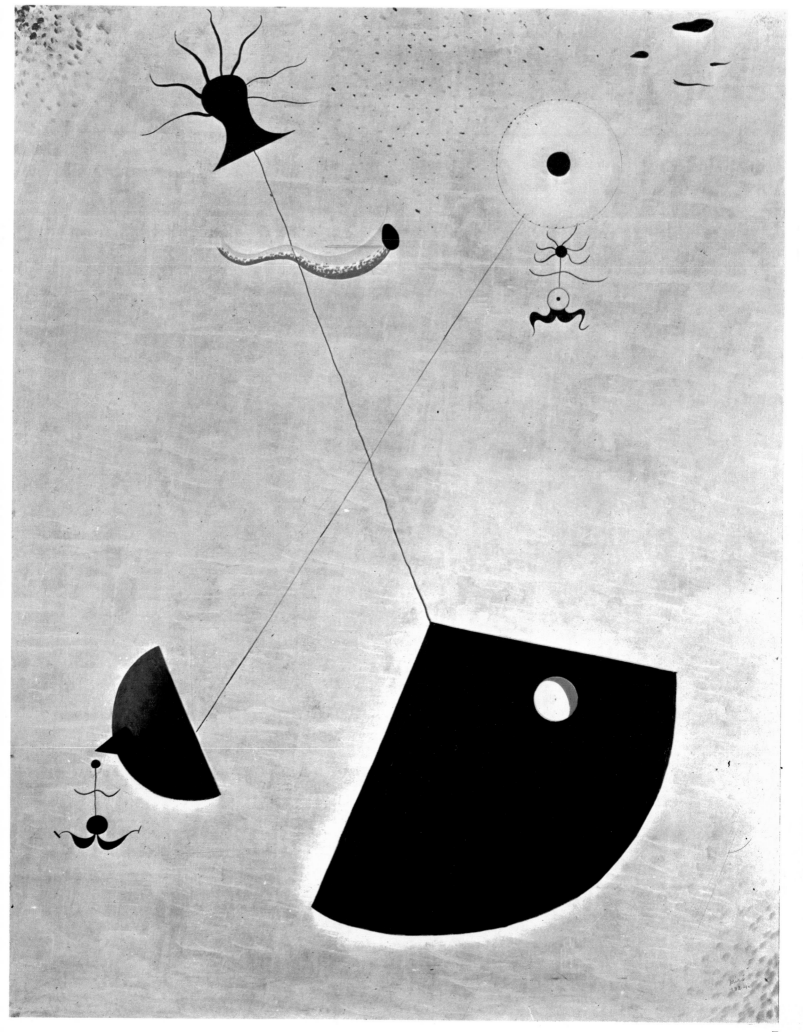

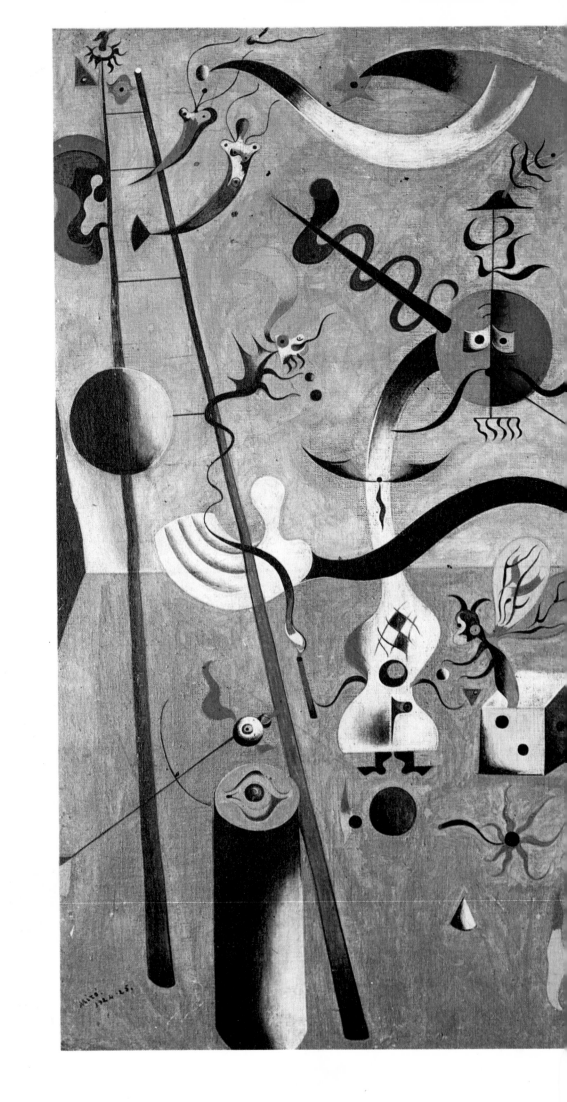

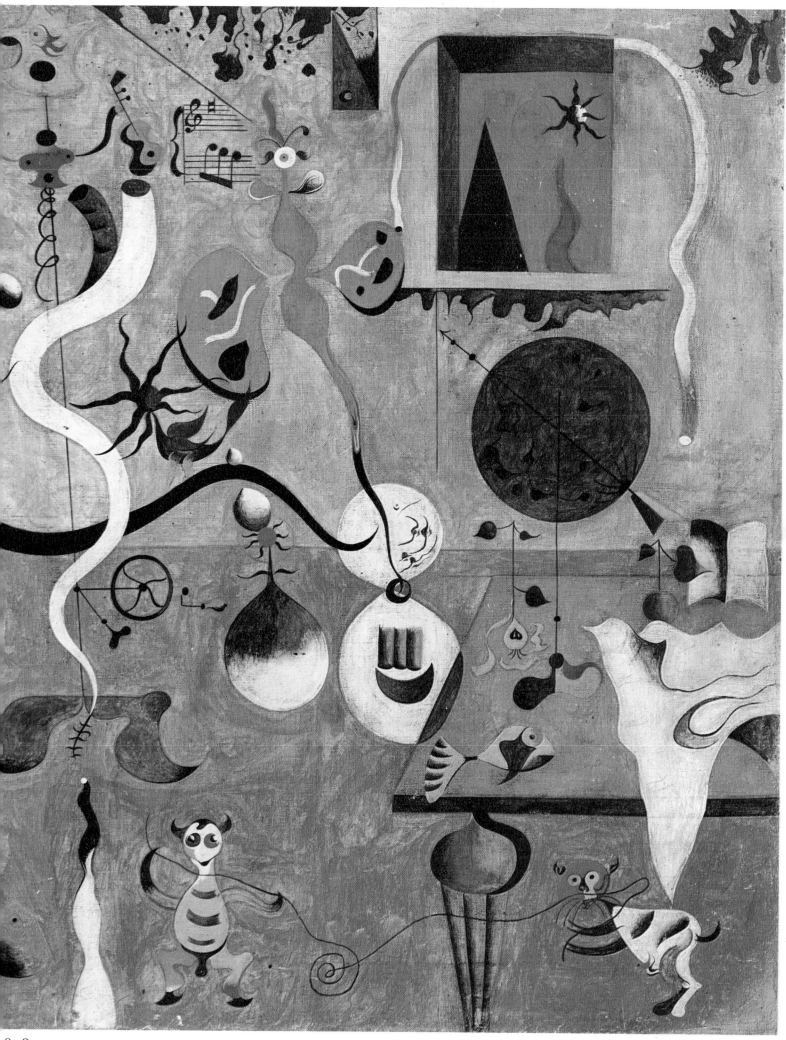

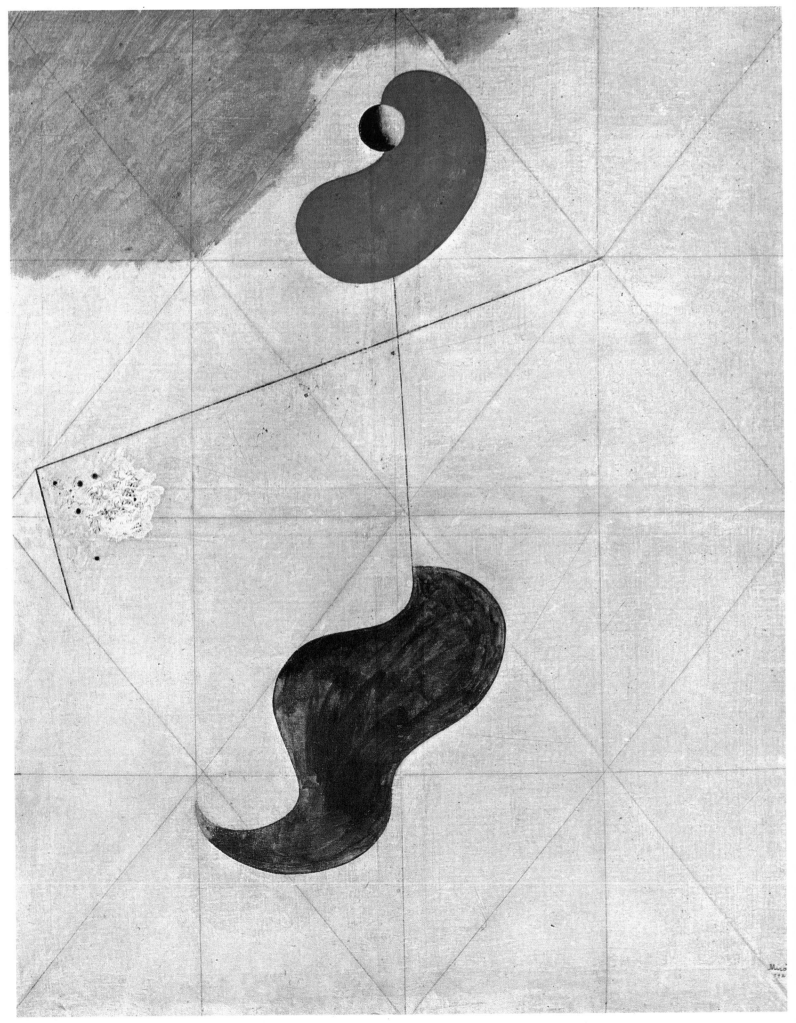

10

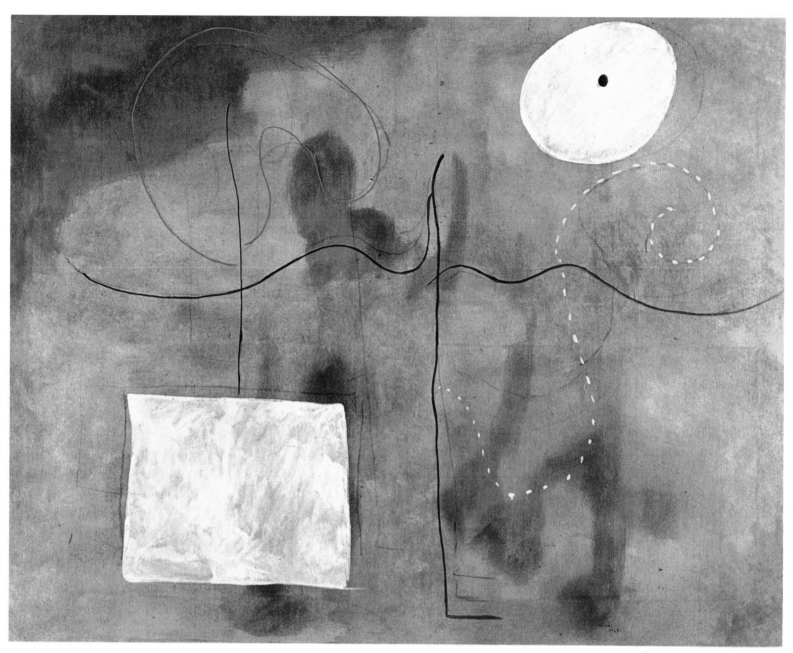

11

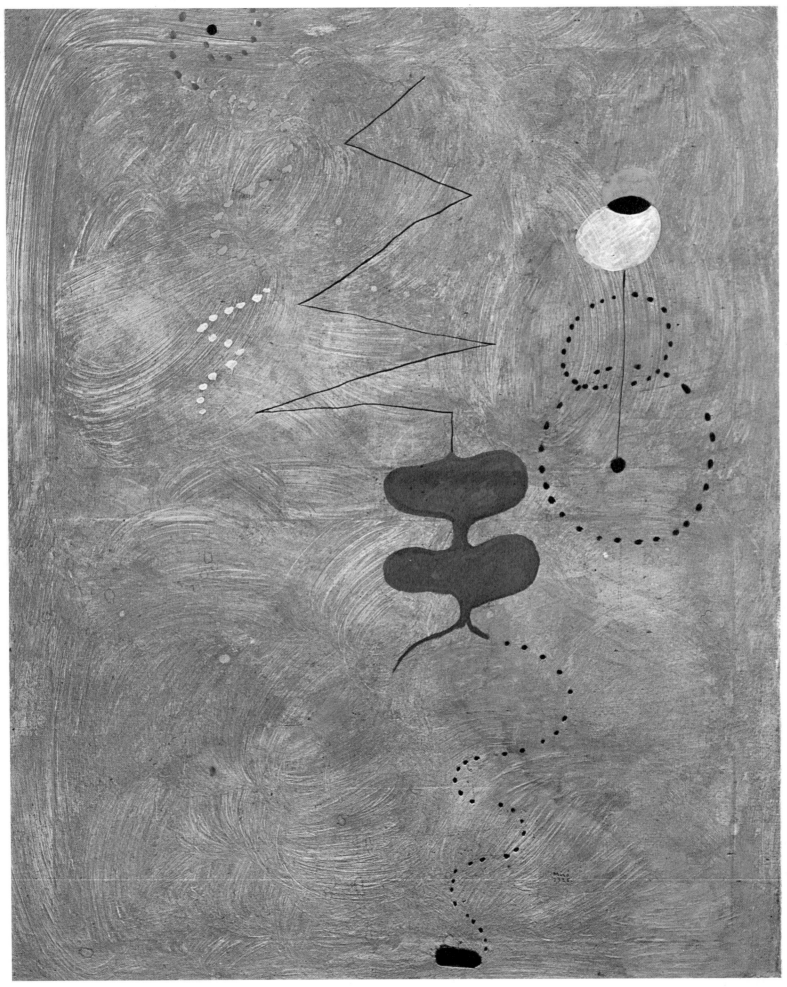

12

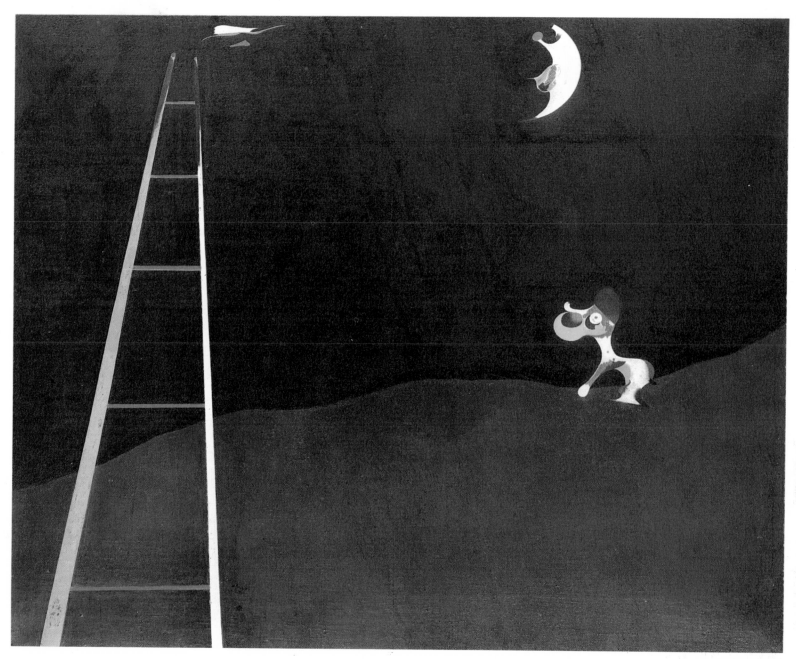

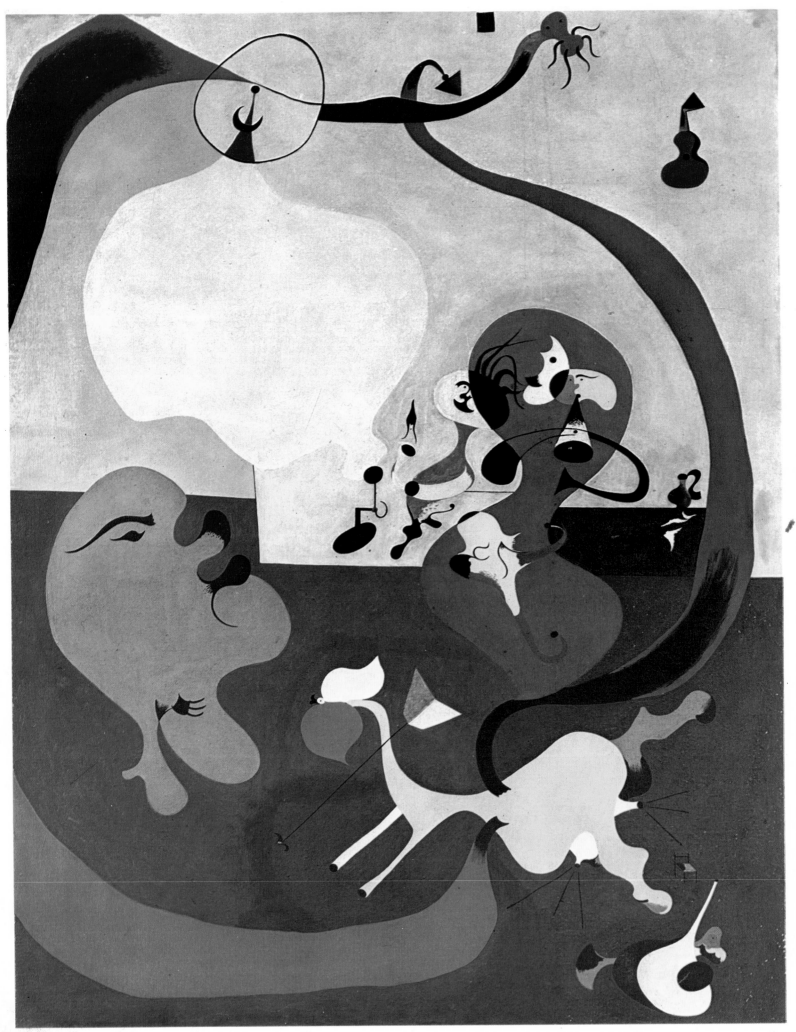

14

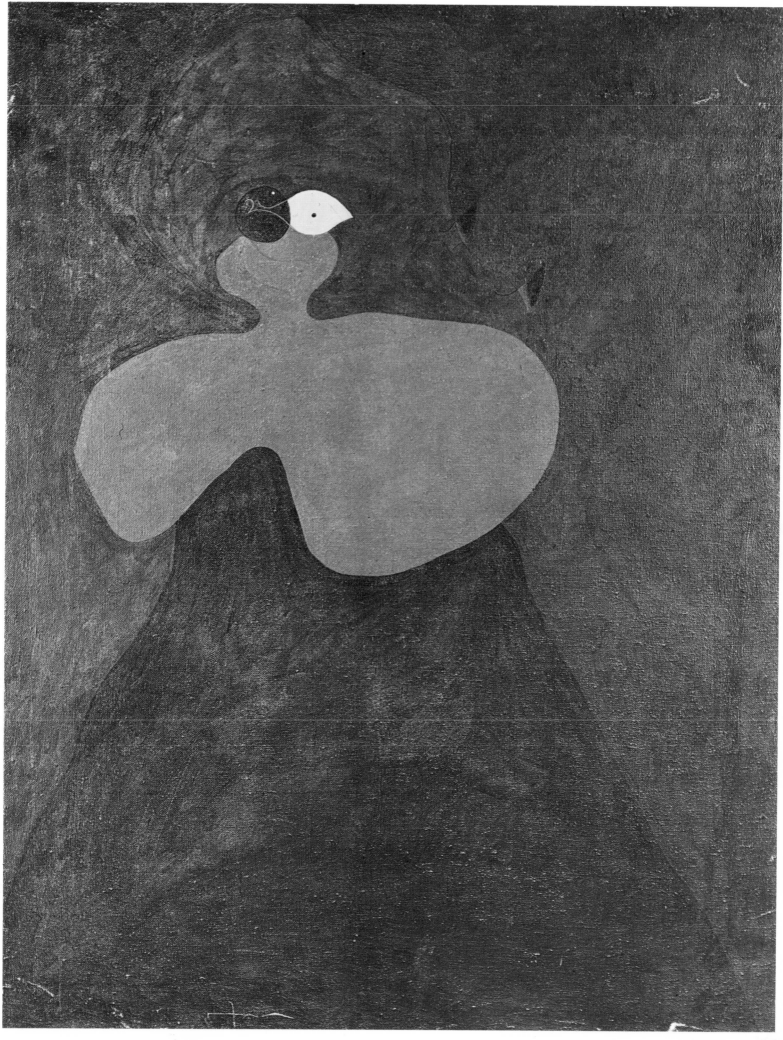

15

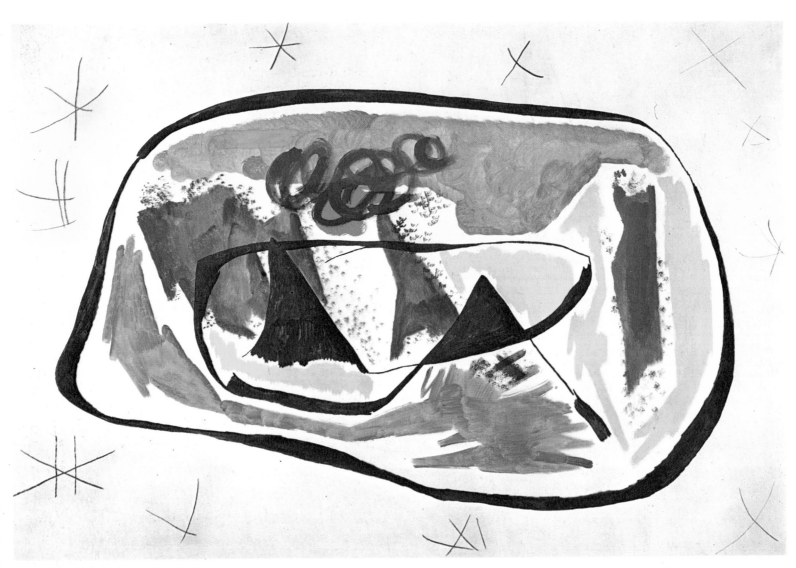

16

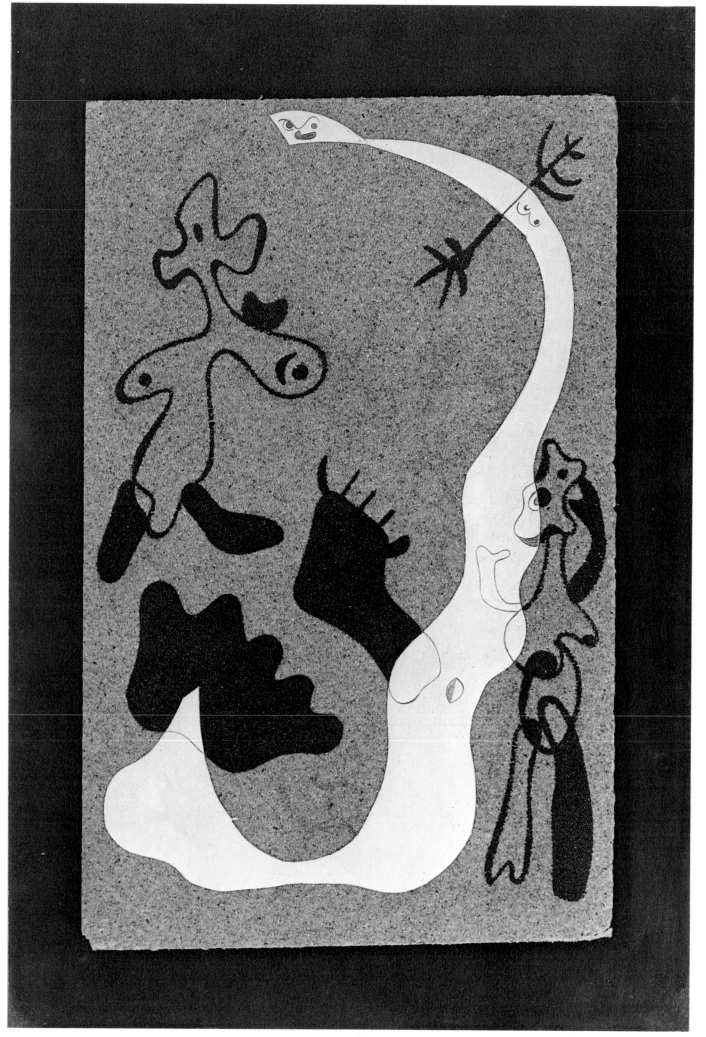

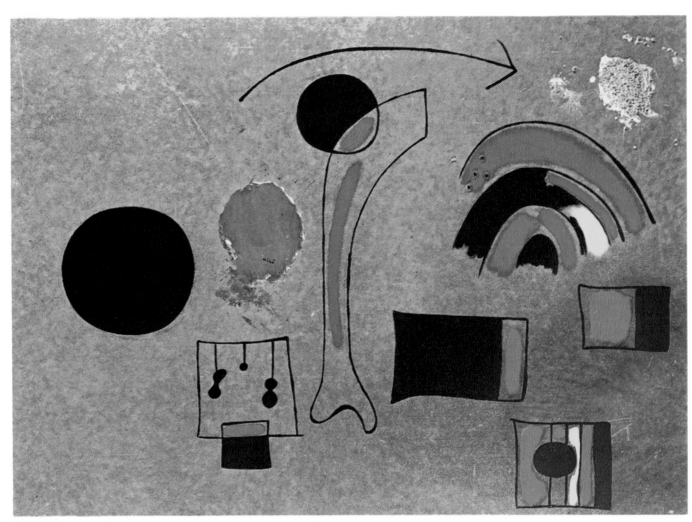

18

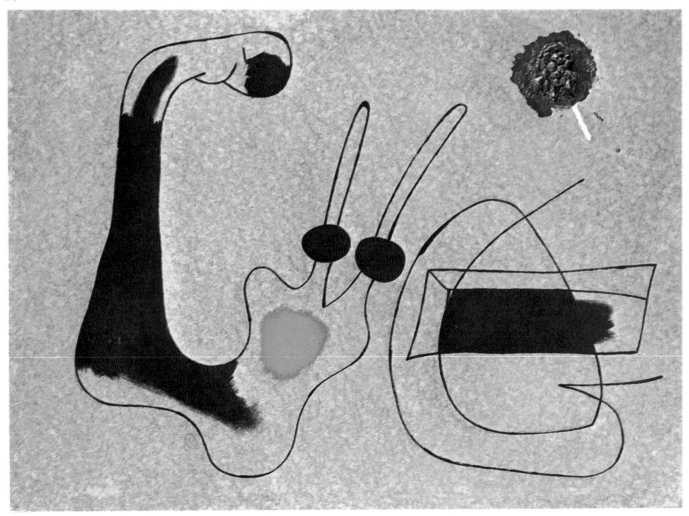

19

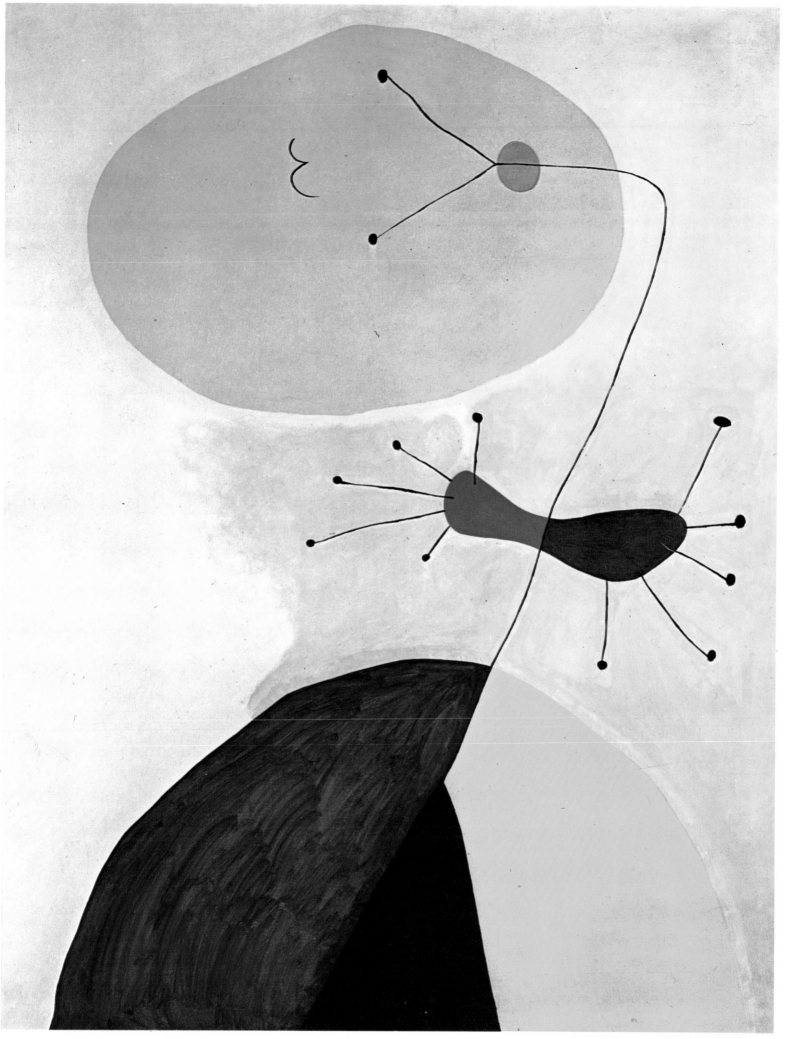

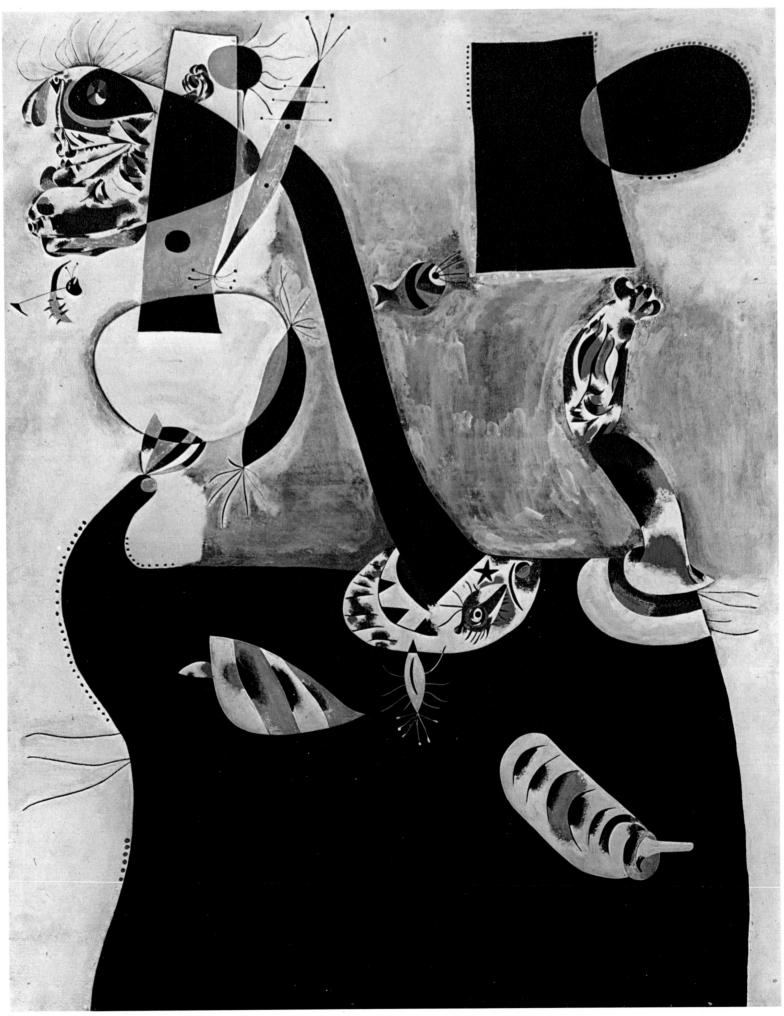

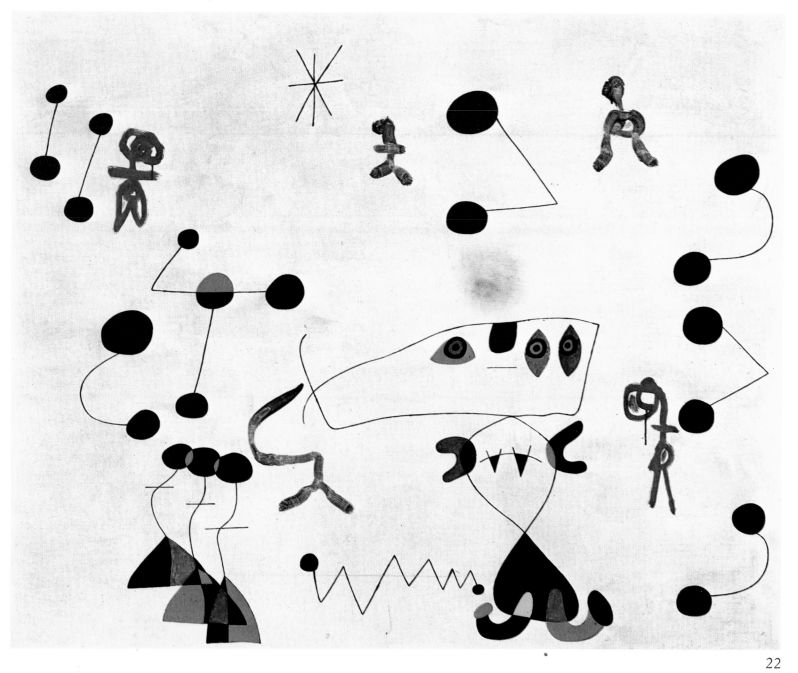

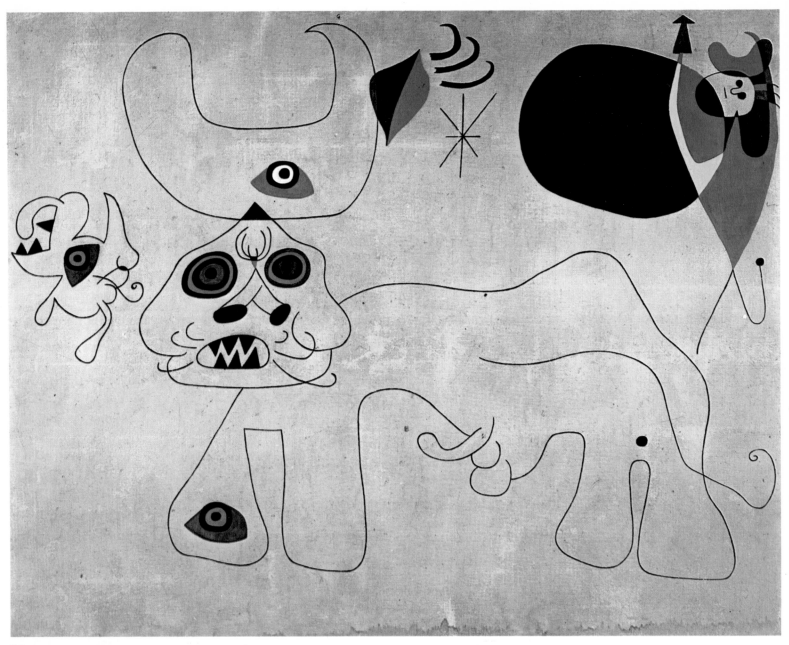

23

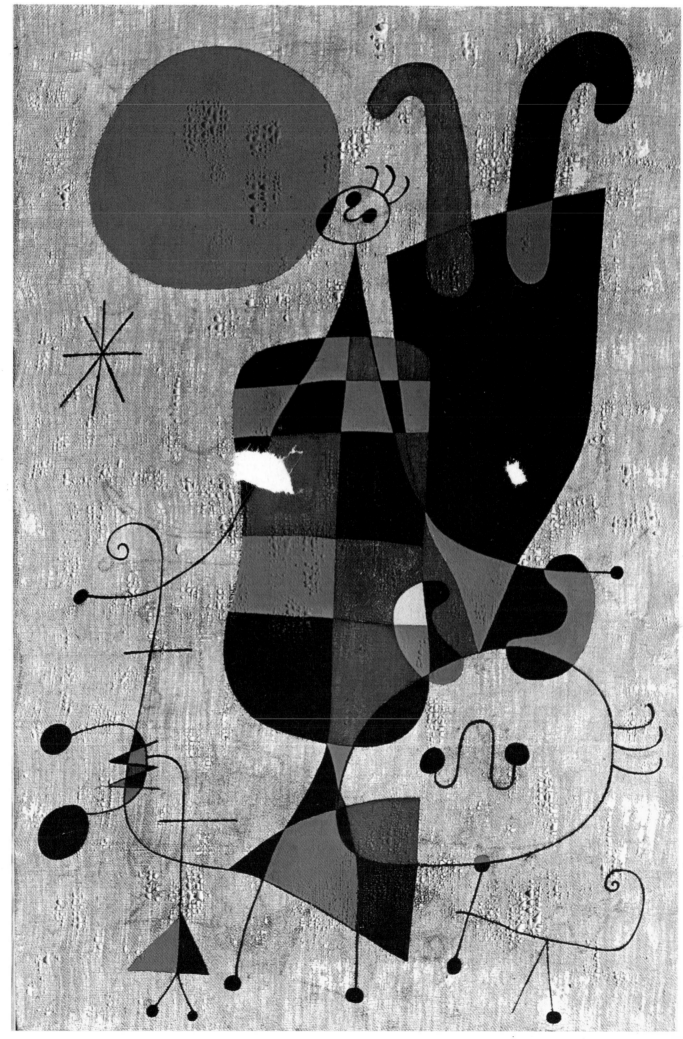

24

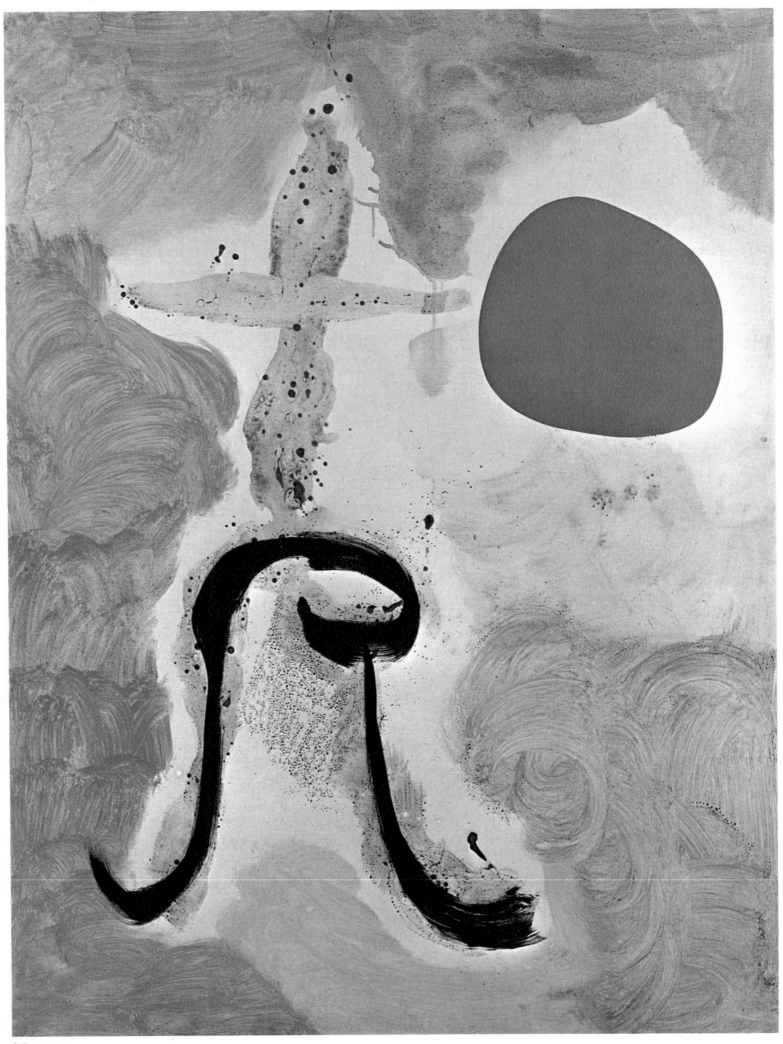

25

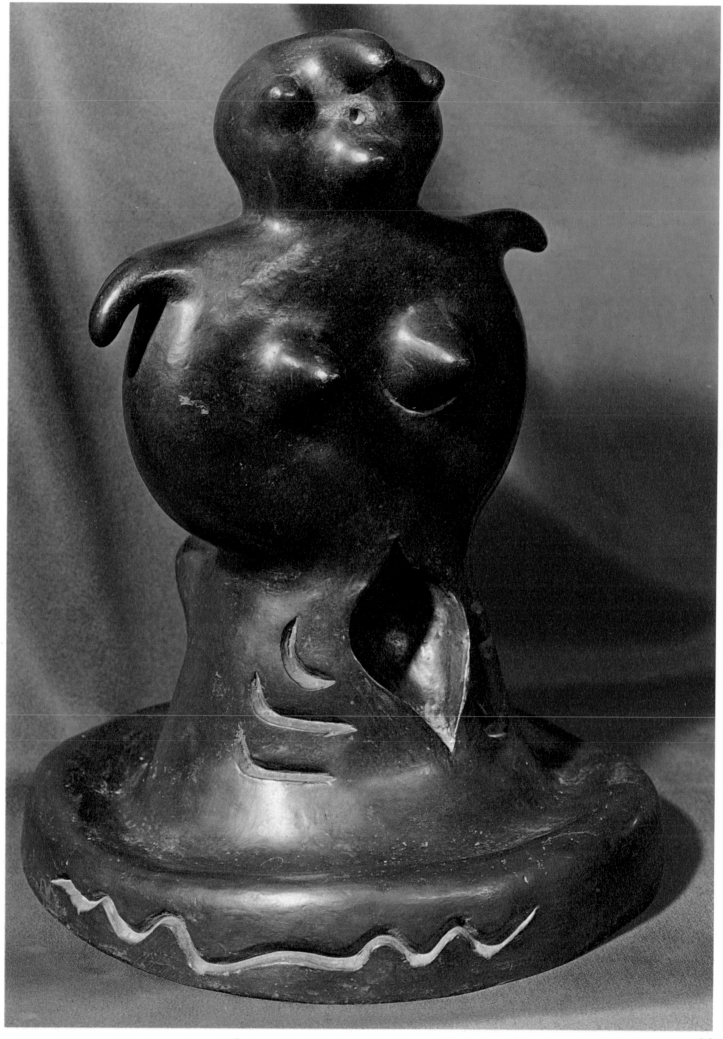

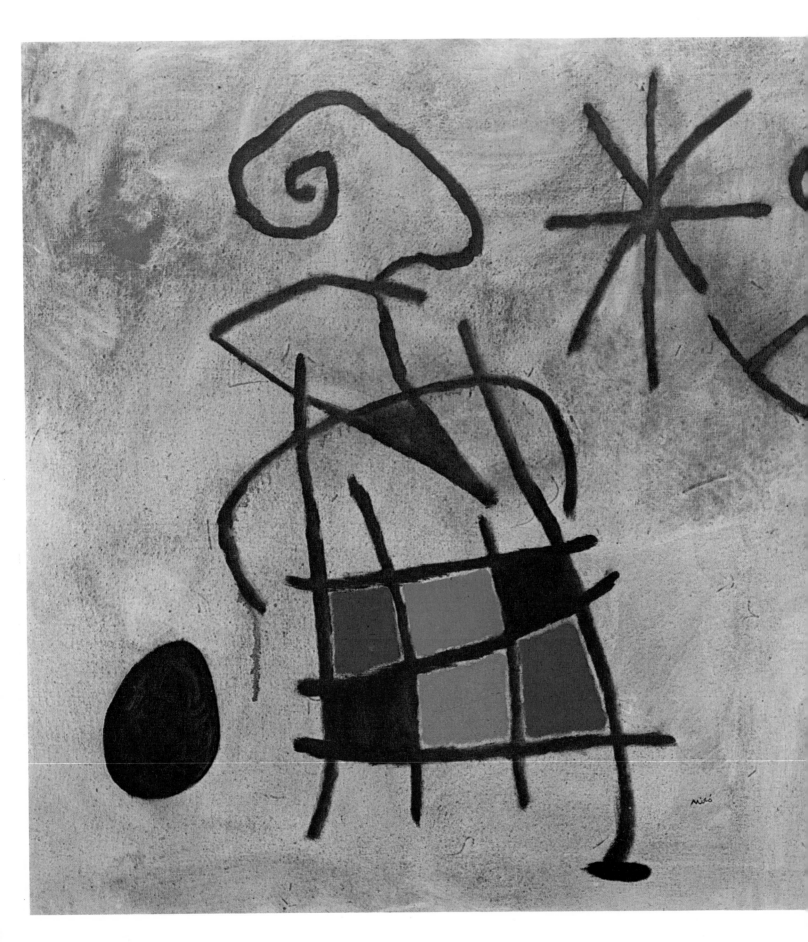

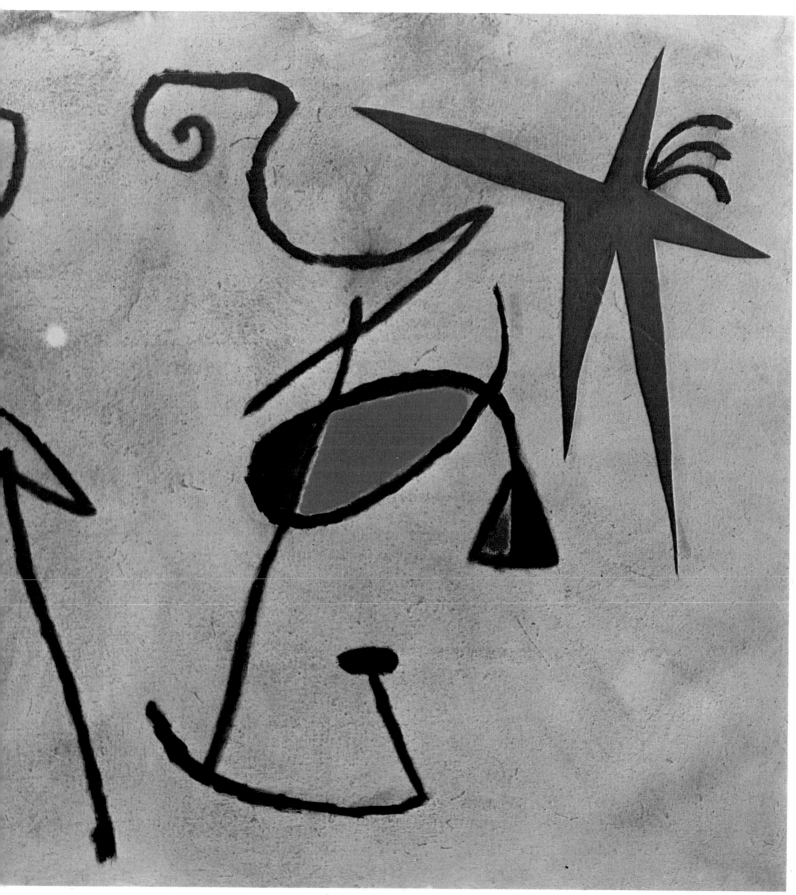

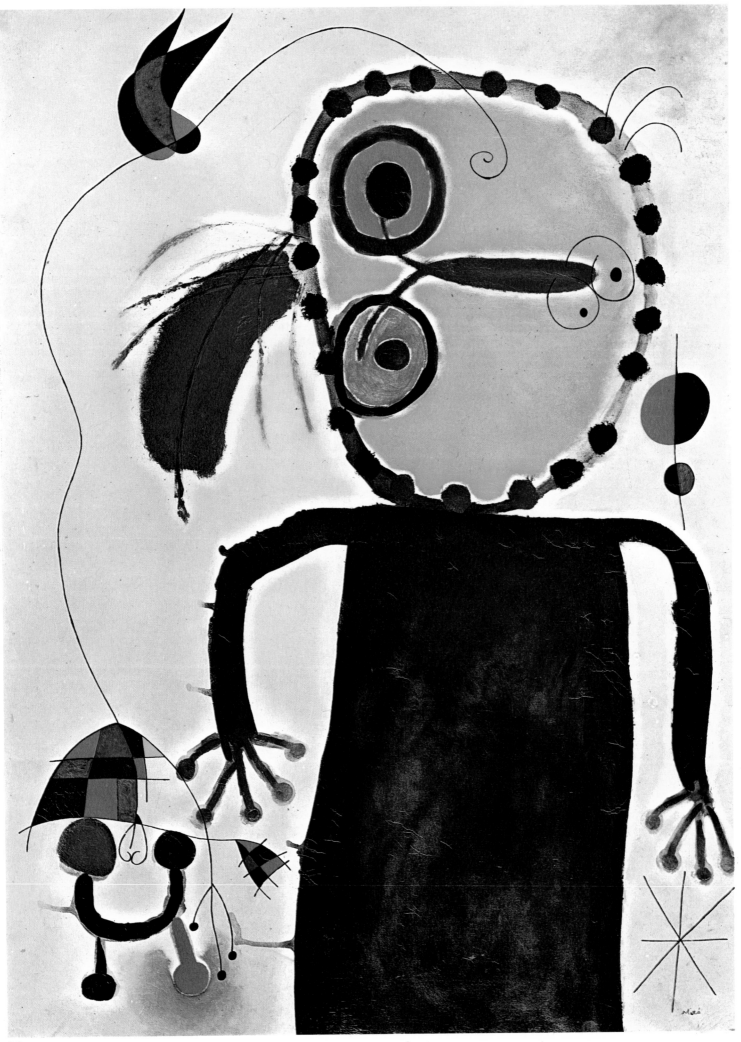

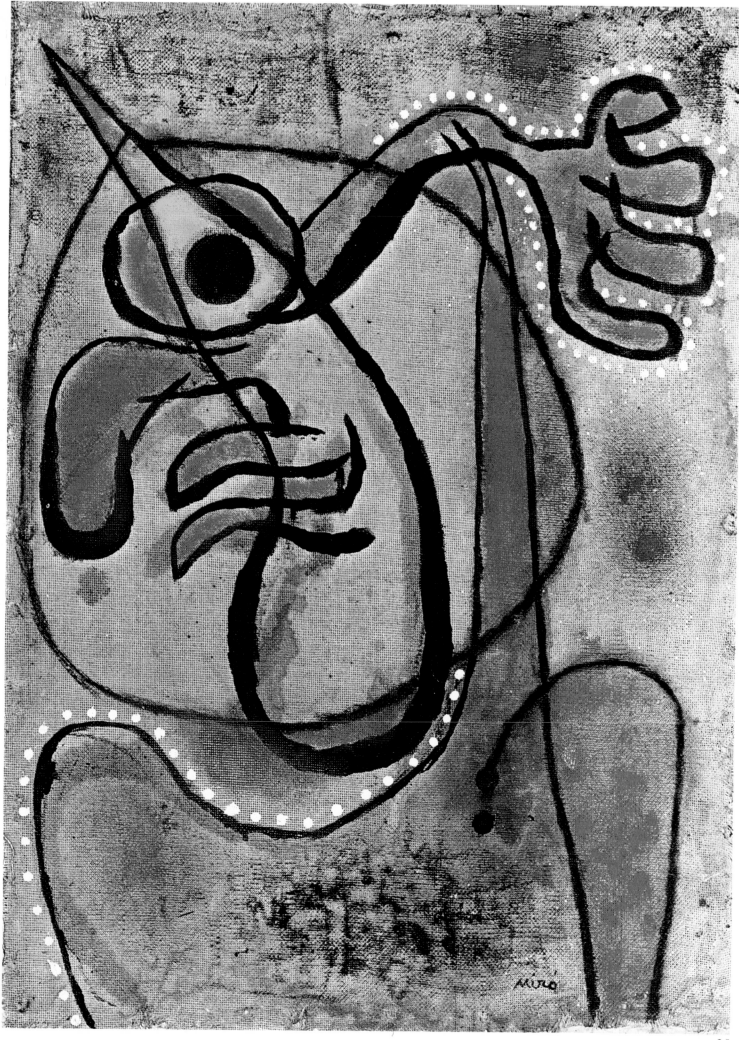

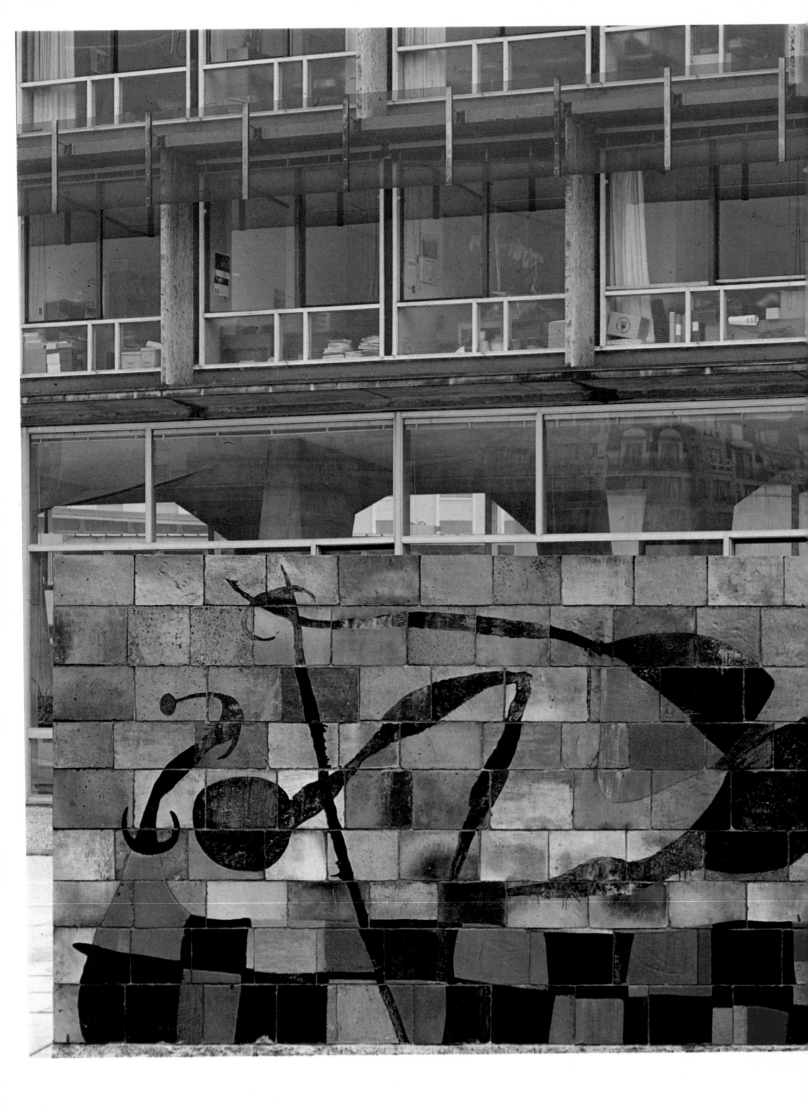

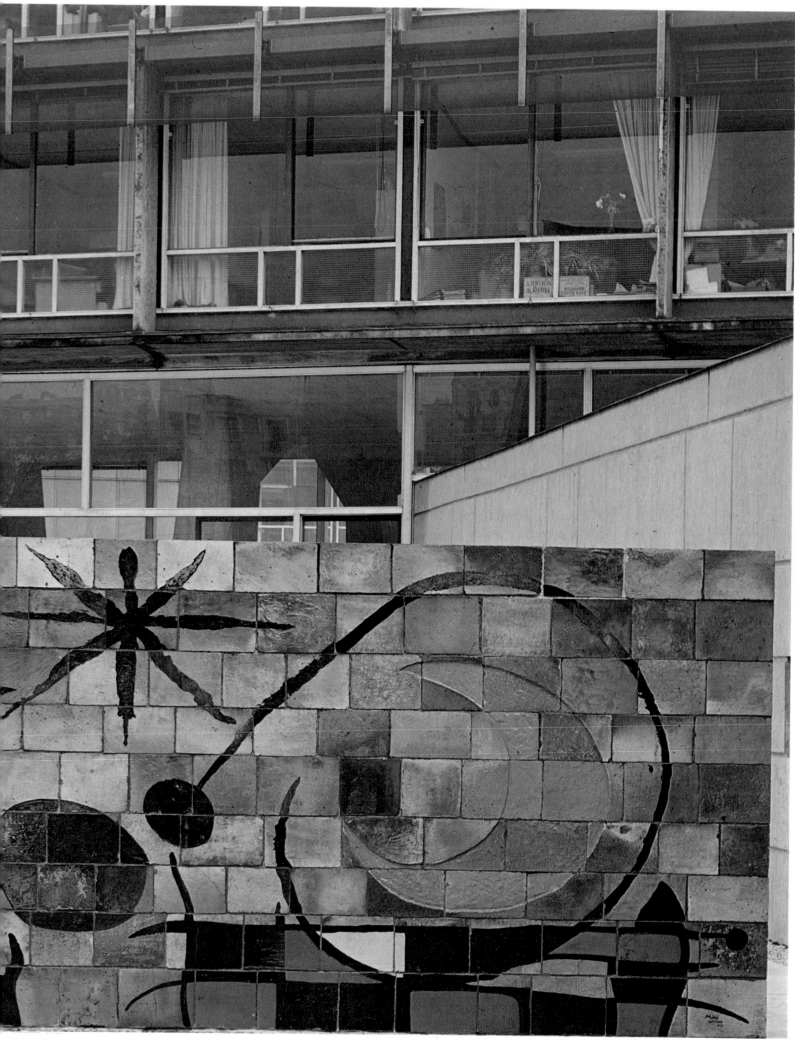

31-32

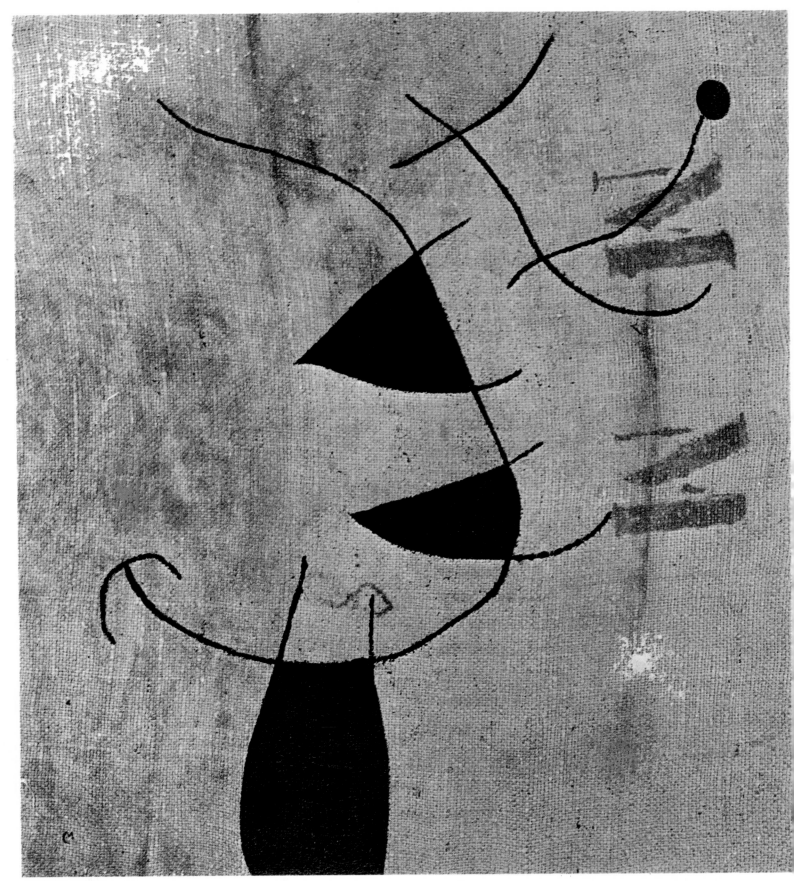

35

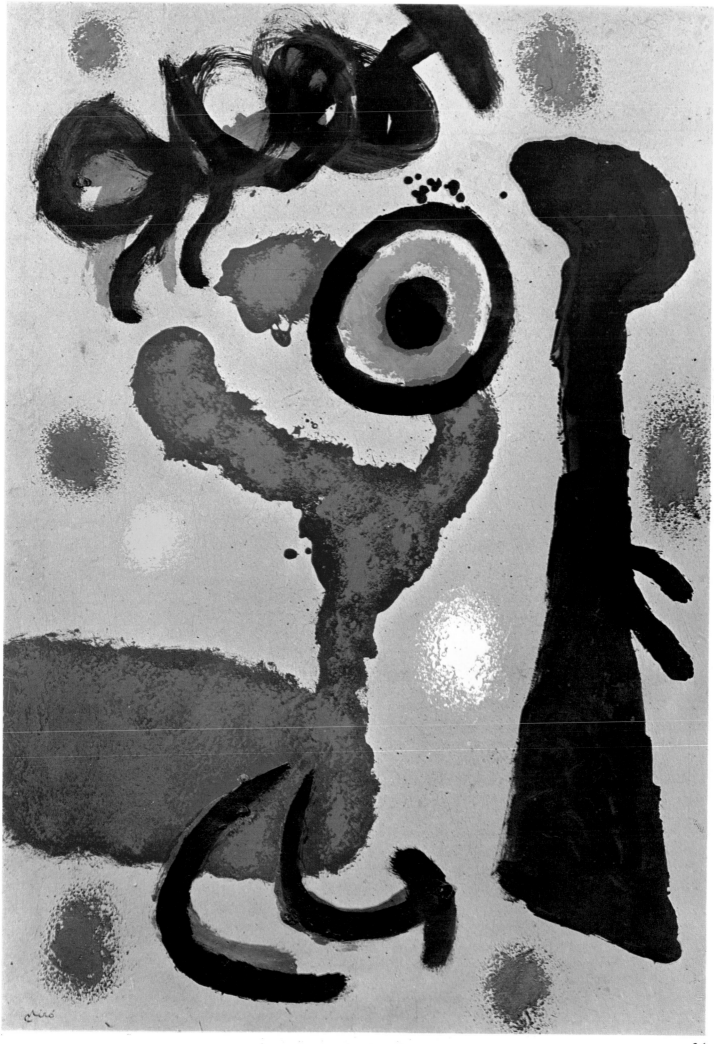

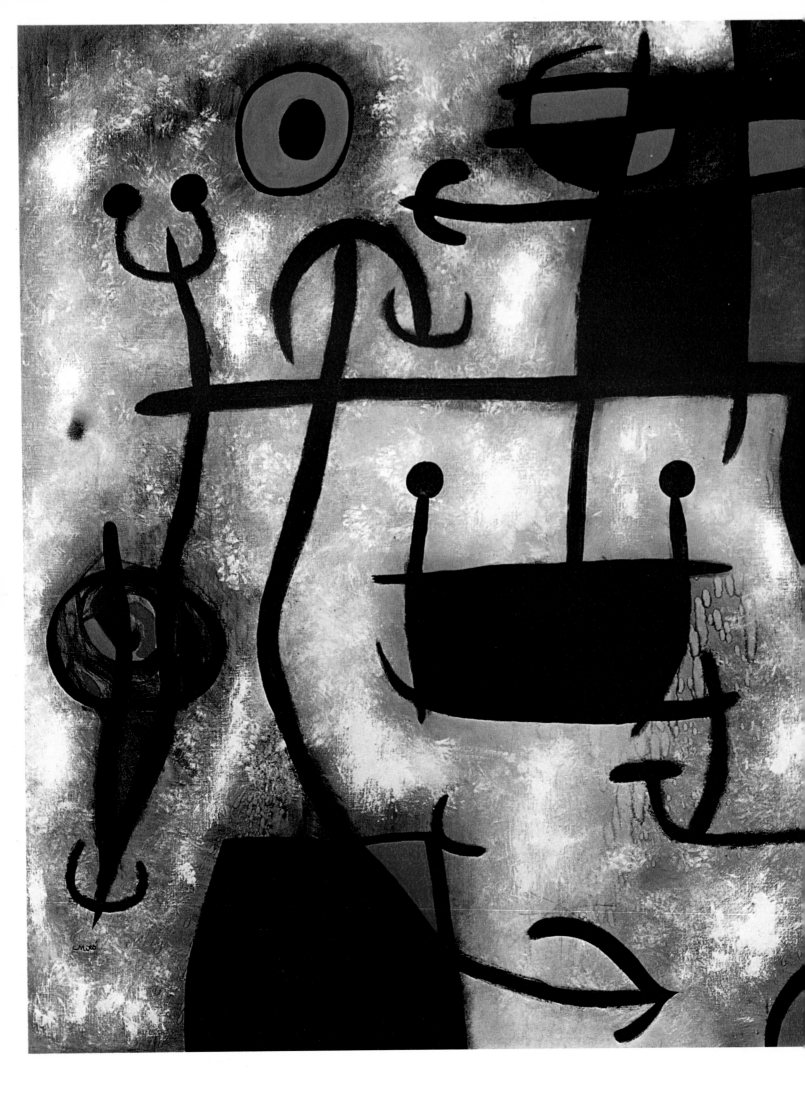

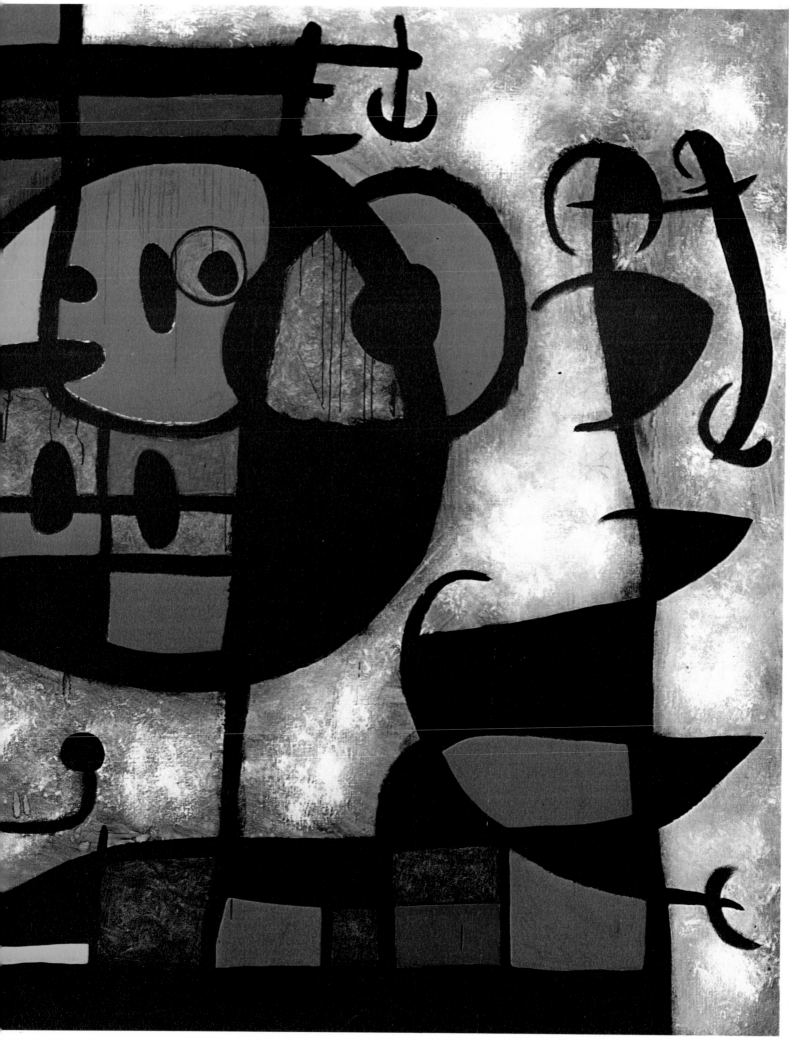

39

41

Description of colour plates

1. *The Peasant*
1912 (?), oil on canvas, $25\frac{5}{8} \times 19\frac{3}{4}$ in (65×50 cm)
Galerie Maeght, Paris

2. *Coffee-pot*
1915, oil on cardboard, $19\frac{3}{4} \times 21\frac{5}{8}$ in (50×55 cm)
Galerie Maeght, Paris

3. *Village of Montroig*
1916, oil on cardboard $23\frac{5}{8} \times 27\frac{1}{4}$ in (60×69 cm)
Pierre Matisse Gallery, New York

4. *The Blue Bottle*
1916, oil on cardboard, $22\frac{1}{2} \times 26\frac{3}{4}$ in (57×68 cm)
Galerie Maeght, Paris

5. *The Path, Ciurana*
1917, oil on canvas, $23\frac{5}{8} \times 28\frac{3}{4}$ in (60×73 cm)
M. E. Tappenbeck collection, Paris

6. *Nude with Bare Feet*
1918, oil on canvas, $59\frac{7}{8} \times 48$ in (152×122 cm)
Pierre Matisse Gallery, New York

7. *Motherhood*
1924, oil on canvas, $35\frac{7}{8} \times 29\frac{1}{8}$ in (91×74 cm)
Roland Penrose collection, London

8–9. *Harlequin's Carnival*
1924–5, oil on canvas, $26 \times 36\frac{5}{8}$ in (66×93 cm)
Albricht-Knox Art Gallery, Buffalo, U.S.A.

10. *Figure*
1925, oil on canvas

11. *Painting*
1925, oil on canvas, $44\frac{7}{8} \times 57\frac{1}{2}$ in (114×146 cm)
Kunsthaus, Basle

12. *Painting*
1925, oil on canvas, $39 \times 31\frac{7}{8}$ in (99×81 cm)
Kunsthaus, Zürich

13. *Dog barking at the Moon*
1926, oil on canvas, $28\frac{3}{4} \times 36\frac{1}{4}$ in (73×92 cm)
Gallating collection, Museum of Modern Art, Philadelphia

14. *Dutch Interior II*
1928, oil on canvas, $36\frac{1}{4} \times 28\frac{3}{4}$ in (92×73 cm)
Peggy Guggenheim collection, Venice

15. *The Baker's Wife*
(after Raphael), 1929, oil on canvas, $57 \times 44\frac{7}{8}$ in (145×114 cm)
Galerie Maeght, Paris

16. *Painting*
1930, oil on canvas, $59 \times 90\frac{5}{8}$ in (150×230 cm)
Galerie d'Art Moderne, Paris

17. Painting-collage on sand-covered cardboard
$14\frac{5}{8} \times 9\frac{1}{2}$ in (37×24 cm)
Gallating collection, Museum of Modern Art, Philadelphia

18. Painting on fibreboard
1936, $40\frac{1}{2} \times 30\frac{3}{4}$ in (108×78 cm)
Galerie Maeght, Paris

19. Painting on fibreboard
1936, $30\frac{3}{4} \times 39\frac{3}{8}$ in (78×100 cm)
Galerie Maeght, Paris

20. *Portrait III*
1938, oil on canvas, $57\frac{1}{2} \times 44\frac{7}{8}$ in (146×114 cm)
Kunsthaus, Zürich

21. *Seated Woman*
1938, oil on canvas $63\frac{3}{4} \times 51\frac{1}{4}$ in (162×130 cm)
Peggy Guggenheim collection, Venice

22. *Woman in the Night*
1945, oil on canvas, $63\frac{3}{4} \times 51\frac{1}{4}$ in (162×130 cm)
Galerie Maeght, Paris

23. *Bull-fight*
1945, oil on canvas, $44\frac{7}{8} \times 57\frac{1}{2}$ in (114×146 cm)
Musée Nationale d'Art Moderne, Paris

24. *Up-turned figures*
9th May, 1949, oil on canvas, $31\frac{7}{8} \times 21\frac{5}{8}$ in (81×55 cm)
Kunsthaus, Basle

25. *Woman facing the Sun*
1949, oil on canvas, $45\frac{3}{4} \times 35$ in (116×89 cm)
Galerie Maeght, Paris

26. *Woman*
1950, bronze, height $12\frac{1}{4}$ in (31 cm)
Galerie Maeght, Paris

27–8. *Painting*
1953, oil on canvas, $49\frac{1}{4} \times 96\frac{1}{2}$ in (125×245 cm)
Galerie Maeght, Paris

29. *Red disc in pursuit of a Lark*
1953, oil on canvas, $51\frac{1}{4} \times 38\frac{1}{4}$ in (130×97 cm)
Galerie Maeght, Paris

30. *Woman trying to attain the impossible*
12th January, 1954, oil on canvas, $27\frac{1}{4} \times 19\frac{3}{4}$ in (69×50 cm)
Galerie Maeght, Paris

31–2. *The Wall of the Moon*
1957, ceramic
UNESCO, Paris

33–4. *Blue II*
4th March, 1961, oil on canvas, $106\frac{3}{8} \times 139\frac{3}{4}$ in (270×355 cm)
Pierre Matisse Gallery, New York

35. *Woman and Bird II/IX*
1960, oil on canvas, $36\frac{1}{4} \times 23\frac{5}{8}$ in (92×60 cm)
Pierre Matisse Gallery, New York

36. *Woman and Bird*
6th April, 1963, oil on canvas
Galerie Maeght, Paris

37. *The Skiing Lesson*
1966
Joan Miró collection, Saint Paul

39. *Land of the Great Fire*
ceramic
Galerie Maeght, Paris

40. *Pumpkin*
ceramic
Galerie Maeght, Paris

41. *Land of the Great Fire*
1955 ceramic, height $19\frac{3}{4}$ in (50 cm)
Galerie Maeght, Paris

Biographical outline

1893. Born in Barcelona, 20th April. His father, a goldsmith and clockmaker, was from the Tarragona region; his uncle, a smith of Cornudella; his mother, daughter of a cabinet-maker, was from Palma, Majorca. Childhood in Barcelona at 4, Pasaje del Credito; summer holidays either at his mother's or at his father's family homes.

1900. Started at the School at 13, Calle Regomir, Barcelona, and studied drawing under Sr Civil.

1901. First drawings.

1905. First books of sketches from nature in the countryside at Tarragona and Palma.

1907. At his father's insistence, attended a commercial school in Barcelona, but at the same time took lessons at the School of Fine Arts of La Lonja, where Picasso had been a pupil ten years earlier; his teachers: Modesto Urgell and José Pasco.

1910. Took a job as a clerk with a commercial concern in Barcelona.

1911. Fell ill with typhus and nervous exhaustion and went into convalescence at Montroig, where his parents had bought a farmhouse; decided to pledge himself entirely to painting.

1912. Started at Gali's School of Art, an avant-garde establishment where he got to know the painting of Monet, Van Gogh, Gauguin, Cézanne, the Fauvists and the Cubists.

1915. Last year at Gali's; frequented the St Lluch Circle, at which Gaudi occasionally appeared. Met the ceramic artist, Artigas, and shared his first studio with his friend, Ricart.

1916. Showed his first canvases to the dealer, Dalmau. Visited the Exhibition of French art organised by Vollard.

1917. Read Apollinaire and Reverdy; met Picabia, who was publicising the Dadaist review, *391,* in Barcelona. First portraits and Montroig landscapes.

1918. First exhibition at the Dalmau Gallery. Was a member of a young group started by Artigas and called the Agrupacio Courbet.

1919. First trip to Paris. Met Picasso who helped him to find his place in the artistic milieu of Paris.

1920. First winter in Paris. Met the Dadaists, Reverdy, Tzara and the critic, Max Jacob. Took a studio in rue Blomet.

1921. First exhibition in Paris, mounted by Maurice Raynal at the La Licorne Gallery. Failure. Started the *Farmhouse,* which he finished the following year.

1922. Together with André Masson, Michel Leiris, Georges Limbour and Antonin Artaud he became a member of the rue Blomet Group.

1923. Met Hemingway and Jacques Prévert.

1924. Met the Surrealist poets, Aragon, Breton and Eluard. Painted *Harlequin's Carnival,* the first in his new style.

1925. Exhibition at the Galerie Pierre, acclaimed by the public and the critics.

1926. Collaborated with Ernst in producing the sets for *Romeo and Juliet* for the Russian ballet.

1927. Took rooms in Montmartre, in rue Tourlaque, near Ernst, Arp and Eluard.

1928. Following a visit to the Netherlands, painted his *Dutch Interiors.*

1929. Married Pilar Joncosa and settled at 3, rue François-Mouthon.

1930. Second exhibition at the Galerie Pierre. First exhibition in the United States. Lithographs for Tzara's *L'Arbre des Voyageurs.*

1931. Daughter Dolores born in Barcelona. Exhibition of object-pictures and paintings on Ingres' card at the Galerie Pierre.

1932. Designed the sets for the ballet, *Jeux d'Enfants,* presented at Monte Carlo. Exhibited at the Galerie Pierre and the Pierre Matisse Gallery in New York.

1933. Collage-drawings and big canvases treated as collages. Exhibition at the Bernheim Gallery.

1934. Pastels marking the beginning of the period of *Salvation* paintings.

1935. Took part in the Surrealist exhibition at Tenerife in the Canaries.

1936. Exhibition of Contemporary Art at the Jeu de Paume Gallery in Paris. Distemper paintings and etchings. Left Spain during the first months of the Civil War, returning only in 1940.

1937. Lived in a hotel in rue Chaplin, Paris, later in an apartment in Boulevard Blanqui. Painted nudes at the Grande Chaumière. Adopted a personal style: *Still-life with Old Shoe.* Painted *The Mower* for the Spanish Pavilion at the Universal Exhibition in Paris.

1939–40. Lived at Varengeville. In 1940 the *Constellations* series started, and in May of the same year he returned to Spain and settled in Palma, Majorca.

1941. The *Constellations* series complete, a retrospective was held at the Museum of Modern Art in New York. First monograph on him, by J. J. Sweeney, published.

1942. Settled at his family home in Barcelona. His mother died.

1944. First ceramics, in collaboration with Artigas.

1945. The *Constellations* and ceramics exhibited at the Pierre Matisse Gallery in New York. Large canvases, *White Backgrounds* and *Grey Backgrounds.*

1947. First trip to the United States. Mural for the *Restaurant des Gourmets* at Cincinnati. Etchings for Tzara's *Antitête.* Exhibition at the Pierre Matisse Gallery.

1948. Return to Paris and exhibition at the Galerie Maeght. Lithographs and woodcuts.

1949. Juvenile works were exhibited at Barcelona. Retrospective at the Kunsthalle, Berne. Action paintings.

1950. Left Pasaje del Credito, where his studio remained, and settled

32. Miró with his parents and sister about 1900
33. Miró in Paris in 1927 with Arp, Mesens and Goemans

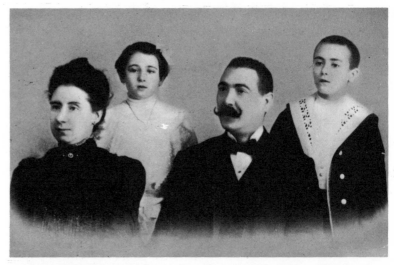

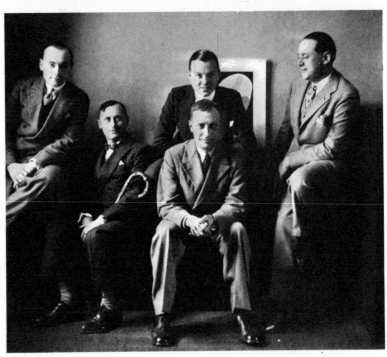

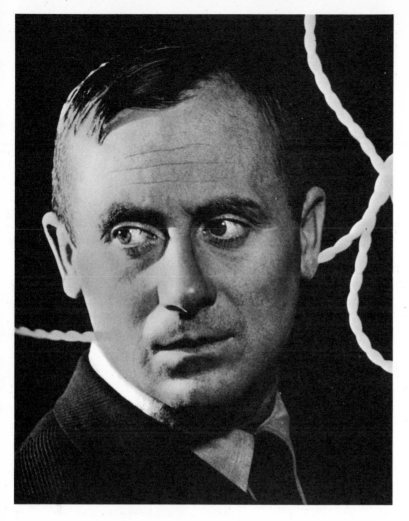

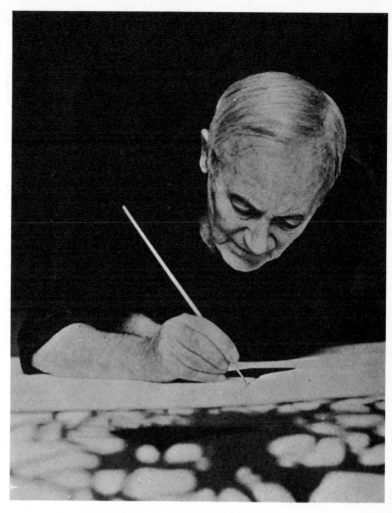

34. Miró about 1930

35. A recent photograph of Miró at work

in Calle Folgarolas. Woodcuts for Cabral de Melo's *Miró*. Exhibition of paintings and sculptures at the Galerie Maeght.

1952. Exhibition at the Kunsthalle, Basle.

1953. Exhibition at the Kunsthalle, Berne, at the Pierre Matisse Gallery and at the Galerie Maeght.

1954. First prize for engraving at the Venice Biennale. Mobile exhibitions for the German galleries. Apart from a few paintings in 1955, no further paintings till 1959.

1954–6. Produced a large series of ceramics with Artigas, exhibited at the Galerie Maeght and the Pierre Matisse Gallery.

1956. Settled for good in Majorca; studio designed by J. L. Sert. Retrospective in Brussels, Amsterdam and Basle.

1957–8. Ceramic panels for the UNESCO building in Paris. Exhibition of graphics in German museums.

1959. Retrospectives at the Museum of Modern Art in New York and the Los Angeles Museum. Travels in the United States. Received the Guggenheim Prize for the UNESCO panels and was officially received at the White House.

1960. Painted the series of new *Paintings*. Worked with Artigas on ceramic panels for Harvard University, which were exhibited in Barcelona. Etchings for *Album 19*, with an introduction by R. Queneau.

1961. Murals *(Blue I, II, III)*. Exhibition of new *Paintings* at the Galerie Maeght and the Pierre Matisse Gallery. Third trip to the United States. Graphics exhibition at Geneva.

1962. Retrospective at the Musée d'Art Moderne in Paris. Publication by Jacques Dupin of a catalogue of his work.

1963. Exhibition at the L'Indiano Gallery, Florence.

1964. Exhibition at the Tate Gallery, London; exhibition of graphic art at the ICA Gallery, London. Other exhibitions at the Sala Gaspar, Barcelona, Galerie Siècle, Paris, and the Ridotto, Turin.

1965. Exhibitions mounted by Dupin at the Cavalero Gallery, Cannes and the Galerie Maeght, Paris. Another exhibition at the Camino Gallery, Pordenone.

Miró's signatures

36.

1916 *The Blue Bottle*

1925 *Painting*

1936 *Painting*

1949 *Painting*

1952 *Graphisme concret*

1955 *Mad dog on a moonlit night haunted by the love-affairs of the birds*

1955 reverse of the preceding picture

1959 *Seated Woman*

1961 for the book *Creacion Miró 1961*, by Y. Taillandier

94

Books and writings illustrated by Miró

As Miró's work as a graphic artist and illustrator is so vast, only the works he illustrated entirely are listed below; those in which other artists also contributed have been omitted. It should be noted that Miró also drew or engraved for many monographs about himself.

J. V. Foix, *Gertrudis in L'Amic de les Arts*, Barcelona, 1926?
L. Hirtz, *Il était une petite pie*, Paris, 1928.
T. Tzara, *L'Arbre des Voyageurs*, Ed. Montaigne, Paris, 1930.
A. Jarry, *Ubu Enchaîné*, Paris, 1937.
R. Todd, *Joan Miró in Tiger's Eye*, Westport, Conn., 1947.
M. Leiris, *Les Gravures de Joan Miró*, New York, 1947.
T. Tzara, *L'Antitête*, Paris, 1947-8.
R. Todd, *Joan Miró in Poetry*, London, 1948.
R. Char, *Fête des Arbres et du Chasseur*, Paris, 1948.
J. Miró, *Album 13*, Paris, 1948.
T. Tzara, *Parler seul: litographies de Joan Miró*, Paris, 1948-50.
J. Cabral de Melo, *Joan Miró*, Ed. de l'Oc, Barcelona, 1950.
Miró in Derrière le Miroir, Paris, 1953.
Miró: Peintures Récentes, Pierre Matisse Gallery, New York, 1953.
R. Char, *A la Santé du Serpent, orné par Joan Miró*, Paris, 1954.
J. Miró, *Une Hirondelle*, Alès, 1954.
Miró-Artigas in Derrière le Miroir, Paris, 1956.
10 Anni di Vita in Derrière le Miroir, Paris, 1956.
P. Eluard, *Un Poème dans chaque Livre*, Paris, 1956.
J. Prévert, G. Ribemont-Dessaignes, *Joan Miró*, Paris, 1956.
J. Miró, *Los Papeles de Son Armadans*, Madrid-Palma, 1956.
A. Verdet, *Joan Miró*, Nice, 1957.
P. Eluard, *A toute épreuve*, Geneva, 1958.
E. Char, *Nous avons*, Paris, 1959.
J. Gomis, V. Prats, *Atmosphère Miró*, Barcelona, 1959.
J. Miró, *Je rêve d'un grand atelier, XX Siècle*, Paris, 1959.
J. Miró, *Constellations*, New York, 1959.
J. T. Soby, *Joan Miró*, New York, 1959.
Miró, ceramic murals for Harvard, Paris, 1961.
Miró, mural paintings, Derrière le Miroir, Paris, 1961.
J. Dupin, *Peintures récentes de Miró in XX Siècle*, Paris, 1961.
M. Leiris, *Marrons Sculptés pour Joan Miró*, Geneva, 1961.
J. Miró, *Recent Paintings at the Pierre Matisse Gallery*, New York, 1961.

Exhibitions and catalogues

As we did with the books illustrated by Miró, we have, in listing his exhibitions, selected only those which mark definite stages both in his career and in the assessment of his work. Thus we have not mentioned various collective exhibitions, except of course those which, like the Venice Biennale, might be considered positive indicators of critical appraisal and the evolution of taste because they provide almost a chronological account of the artistic production of their period.

1918. Galleria Dalmau, Barcelona. 16th February–5th March. Catalogue by J. M. Junoi.

1921. Galerie La Licorne, Paris. 21st April–14th May. Catalogue by M. Raynal.

1925. Galerie Pierre, Paris. 12th–17th June. Catalogue by B. Péret.

1928. Galerie Georges Bernheim et Cie, Paris. 1st–15th May.

1929. Galerie Le Centaure, Brussels. 11th–22nd May.

1930. Galerie Goemans, Paris. March. Catalogue by L. Aragon; Galerie Pierre, Paris. 7th–22nd May; Valentine Gallery, New York. October–November; Studio 28, Paris. 28th November–5th December; Gallery of Living Art, New York.

1931. Arts Club of Chicago. 27th January–17th February; Galerie Pierre, Paris. 18th December–8th January.

1932. Ballets russes de Monte-Carlo, Monte Carlo. 14th April; Pierre Matisse Gallery, New York. 1st–25th November; Galerie Pierre Colle, Paris. 13th–16th December.

1933. Galerie Pierre Colle, Paris. 7th–18th June; Pierre Matisse Gallery, New York. 29th December–18th January. Catalogue by E. Hemingway and J. J. Sweeney; Galerie Pierre, Paris. 30th October–15th November.

1934. Galerie des Cahiers d'Art, Paris. 3rd–19th May.

1935. Pierre Matisse Gallery, New York. 10th January–9th February; Gaceta de Arte, Tenerife, Canary Islands. 11th–21st May.

1936. Pierre Matisse Gallery, New York. 30th November–26th December.

1937. Musée du Jeu de Paume, Paris. July–November.

1938. Galerie Beaux-Arts. January–February; Pierre Matisse Gallery, New York. 19th April–7th May; Mayor Gallery, London. 4th–28th May.

1940. Pierre Matisse Gallery, New York. May; Museum of Modern Art, New York. Catalogue by J. J. Sweeney.

1942. Co-ordinating Council of French Relief Societies, New York. 14th October –7th November; Museum of Modern Art, New York. Catalogue by A. H. Barr.

1945. Galerie Vendôme, Paris. 27th March–28th April. Catalogue by L. Parrot.

1946. Institute of Contemporary Art, Boston. 24th January–3rd March.

1947. Pierre Matisse Gallery, New York. 13th May–7th June.

1948. Pierre Matisse Gallery, New York. 16th March–10th April; Museum of Art, San Francisco. 14th September–17th October; *Derrière le Miroir*, Galerie Maeght, Paris. 19th November–18th December. Catalogue by Tzara, Cassou, Prats-Vallès, Queneau, Duthuit, Zervos, Limbour, Gomis, Eluard, Kahnweiler, Deharme, Raynal, Loeb, Artigas.

1949. Galerie Blanche, Stockholm. 9th April–3rd May. Catalogue by R. Hoppe; Pierre Matisse Gallery, New York. 6th–13th December; Kunsthalle, Berne. 21st April–29th May; Kunsthalle, Basle. 14th June–17th July.

1950. Galerie Blanche, Stockholm. November.

1951. Pierre Matisse Gallery, New York. 6th–31st March; Mary Cershinowitz, Houston. 14th October–4th November; Galleria del Naviglio, Milan. 8th–21st December. Catalogue by G. Dorfles.

1953. Galerie Maeght, Paris. June–August.

1954. Kaiser-Wilhelm Museum, Krefeld. January–February. Catalogue by R. Wember, W. Grohmann; Venice Biennale. 19th June–17th October.

1956. Palais des Beaux-Arts, Brussels. 6th January–7th February; Kunsthalle, Basle. 24th March–29th April; Pierre Matisse Gallery, New York. December; Galerie Maeght, Paris. June–August. Catalogue by Artigas, Prévert and Ribemont-Dessaignes.

1957. Pierre Matisse Gallery, New York. 13th May–7th June; Kaiser-Wilhelm Museum, Krefeld. Catalogue by P. Wember.

1958. Collection Berggruen, Paris; Pierre Matisse Gallery, New York. 4th–29th November. Catalogue by James Fitzsimmons.

1959. Collection Berggruen, Paris. Catalogue by Breton; Galleria Il Segno, Rome. 7th March–4th April; Museum of Modern Art, New York. Catalogue by W. Liebermann.

1961. Sala Gaspar & Club 49, Barcelona. 31st January–February; Galleries Perls, New York. 21st February–1st April; Galerie Maeght, Paris. February. Catalogue by J. G. Artigas; Galerie Maeght, Paris. April. Catalogue by R. Char and J. Dupin; Galerie Maeght, Paris. June. Catalogue by J. L. Sert, J. Prats and J. Brossa; Pierre Matisse Gallery, New York. October.

Bibliography

MIRÓ'S WRITINGS

Below are listed Miró's writings, either published as such, or – where particularly important – appearing in essays about him. Odds and ends such as interviews have been omitted where they make little contribution to a complete understanding of his character.

J. Miró, *Declaraciones, La Publicitat*, Barcelona, 1928.

In M. Leiris' *Joan Miró, Documents*, Paris, 1929.

J. Miró, *Declaraciones, Ahora*, Madrid, 1931.

J. Miró, *Declaraciones, Minotaure*, Paris, 1933.

in G. Duthuit's *Où allez-vous, Miró?, Cahiers d'Art*, Paris, 1955.

J. Miró, *Je rêve d'un grand atelier, XX Siècle*, Paris, 1958.

J. Miró, *Le Carnaval d'Arlequin, Verve*, Paris, 1939.

J. Miró, *Jeux poétiques, Cahiers d'Art*, Paris, 1945–46.

In R. Bernier's *Miró céramiste, L'Œil*, Paris, 1956.

J. Miró, (correspondence concerning *A·toute épreuve*), Barcelona, 1947–56.

In E. Scheidegger, *Joan Miró: Gesammelte Schriften, Photos, Zeichnungen*, Zürich, 1957.

J. Miró, *Sur 4 Murs, Derrière le Miroir*, Paris, 1958.

J. Miró, *Je travaille comme un jardinier, XX Siècle*, Paris, 1959.

J. Miró, *Thoughts, Daedalus*, Cambridge, 1960.

J. Miró, *Thoughts, L'Œil*, Paris, 1961.

MONOGRAPHS AND ESSAYS IN BOOKS AND PERIODICALS

This bibliography may be considered complete in that it mentions those works which have made a positive contribution to criticism of Miró's work. It does not of course include the innumerable journalistic pieces about the painter's habits and tastes rather than his attitudes and his work.

M. JACOB, *An unpublished document from Max Jacob to Joan Miró, 29th May, 1922, Cobalto 49*, Barcelona, 1950; L. ARAGON, A. BRETON, *Protestation, La Révolution Surréaliste*, Paris, 15th June, 1926; M. LEIRIS, *Joan Miró, Little Review*, New York, Spring/Summer, 1926; J. GASCH, *L'Obra del Pintor Joan Miró, L'Amic de les Arts*, Sitges, August, 1926; S. DALÌ, *Joan Miró, L'Amic de les Arts*, Sitges, 30th June, 1928; M. A. CASSANYES, *Joan Miró, L'Amic de les Arts*, Sitges, 30th June, 1928; J. V. FOIX, *Presentacie de Joan Miró, L'Amic de les Arts*, Sitges, 30th June, 1928; S. GASCH, *Joan Miró, L'Amic de les Arts*, 30th June, 1928; S. GASCH, *Joan Miró, Gaceta de les Arts*, Barcelona, March, 1929; W. GEORGE, *Miró et le miracle ressuscité, Le Centaure*, Brussels, May, 1929; J. DALI, R. DESNOS, S. GASCH, W. GEORGE, *Le Surréalisme en 1929, Cahiers de Belgique*, Brussels, June, 1929; L. ARAGON, A. BRETON, *Continua*, Brussels, June, 1929; C. EINSTEIN, *Joan Miró; papiers collés à la Galerie Pierre, Documents*, Paris, 1930; G. HUGNET, *Joan Miró, ou l'enfance de l'art, Cahiers d'Art*, Paris, 1931; C. ZERVOS, *L'Œuvre de Joan Miró de 1917 à 1933, Cahiers d'Art*, Paris, 1934; J. CASSOU, *Le Dadaisme et le Surréalisme, Amour de l'Art*, Paris, March, 1934; M. A. CASSANYES, *Joan Miró, el Extraordinario, A.C.*, Barcelona, 1935; M. HENRY, *Joan Miró, Cahiers d'Art*, Paris, 1935; WESTERDAHL, R. HOPPE, V. HUIDOBRO, L. MASSINE, C. ZERVOS, *Joan Miró, Gaceta de Arte*, Tenerife, June, 1936; J. G. JREY, *Miró and the Surrealists, Parnassus*, New York, October, 1936; J. VIOT, *Un Ami, Joan Miró, Cahiers d'Art*, Paris, 1936; P. ELUARD, *Naissance de Miró, Cahiers d'Art*, Paris, 1937; G. L. K. MORRIS, *Miró and the Spanish Civil War, Partisan Review*, New York, February, 1938; R. TODD, *For Joan Miró (poetry), London Bulletin*, London, 15th April, 1939; L. VARGAS, *Joan Miró, Konstrevy*, Stockholm, 1939; G. HUGNET, *Joan Miró (poetry), Cahiers d'Art*, Paris, 1940; J. J. SWEENEY, *Joan Miró*, New York, 1941; M. BROWN, *The Miró exhibition at the Pierre Matisse Gallery, Parnassus*, April, 1941; P. WATSON, *Joan Miró, Horizon*, London, August, 1941; D. PUCINELLI, *The Miró Exhibition at the San Francisco Museum, California Arts and Architecture*, July, 1942; R. MORTENSEN, *Joan Miró, Klingen*, Fischer, Copenhagen, 1942; *Miró, Norte*, New York, January, 1943; J. J. SWEENEY, *Joan Miró, Ars*, Mexico, May, 1943; C. GREENBERG, *Art, The Nation*, New York, 20th May, 1944; C. GREENBERG, *Miró's Mirror Magic, Town and Country*, New York, April, 1943; C. ZERVOS, *Joan Miró; opere 1944–6, Cahiers d'Art*, Paris, 1945–6; M. AGUELAR, *Ode de poche pour Joan Miró, Cahiers du Sud*, Marseilles, 1946; P. GASSIER, *Miró et Artigas, Labyrinthe*, Geneva, 1946; M. LEIRIS, *Joan Miró's Etchings*, New York, 1947; H. JUIN, *Poème mesquin pour Joan Miró, Arts de France*, Paris, 1947; G. LIMBOUR, *Souvenirs sur un peintre, Joan Miró, Arts de France*, Paris, 1947; F. LEE, *Interview with Miró, Possibilities*, New York, Winter, 1947–48; J. GOMEZ SICRE, *Joan Miró in New York, Right Angle*, Washington, January, 1948; A. DE GUSMAO, *A ceramica de Joan Miró, Arquitectura portuguesa ceramica e edificaçao reunidas*, Lisbon, 1948; J. F. RAFOLS, *Miró antes de la Masia*, Barcelona, 1948; J. T. SOBY, *Mural for Cincinnati's Plaza Hotel; Architectural Forum*, New York, April, 1948; R. QUENEAU, *Joan Miró ou le poète préhistorique. Trésors de la peinture francaise*, Geneva, 1949; A. CIRICI-PELLICER, *Miró y la imaginacion*, Barcelona, 1949; J. E. CIRLOT, *Joan Miró*, Barcelona, 1949; J. J. SWEENEY, *Miró, Theatre Arts*, New York, March, 1949; J. BROSSA, *Joan Miró dels ventalls, Dau al Set*, Barcelona, May, 1949; G. DORFLES, *Per Joan Miró, Critica d'Arte*, Florence, November, 1949; C. ZERVOS, *Remarques sur les œuvres de Miró, Cahiers d'Art*, Barcelona, 1949; J. CABRAL DE MELO, *Joan Miró*, Barcelona, 1949. *Portrait of the Artist. Art News and Review*, London, 28th January, 1950; T. R. SANTOS, *Joan Miró en su estudio, Indice de las Artes*, Madrid, February, 1950; R. QUENEAU, *Miró, ou le poète préhistorique; Bâtons, chiffres et lettres*, Paris, 1950; T. BOUCHARD, *Joan Miró composing a coloured engraving* (film), New York, 1951; *Miró, Painter of Reality, Art Digest*, New York, 1st December, 1951; *Joan Miró, Lithographies, Verve*, Paris, December, 1952; G. DUTHUIT, *Joan Miró* (Japanese text), *Mizue*, Tokyo, 1953; G. SCHIFF, *Gespräche mit spanischen Malern: Dali, Joan Miró, Kunstwerk*, Baden-Baden, 1953; J. J. SWEENEY, *Miró, Art News*, New York, November, 1953; H. HILDEBRANDT, *Miró alla Galleria Nazionale di Stoccarda, Werk*, Zürich, May, 1954; A. CIRICI-PELLICER, *Miró e la XXVII Biennale di Venezia*, Clavilens, 1955; *Miró vous montre Barcelone, L'Œil*, Paris, Summer, 1955; T. BOUCHARD, *Around and about Miró* (film), New York, 1956; J. PRÉVERT, G. RIBEMONT-DESSAIGNES, *Joan Miró*, Paris, 1956; P. COURTHION, *Jeux et fantaisies de Miró, XX Siècle*, Paris, January, 1956; R. BERNIER, *Miró Céramiste, L'Œil*, Paris, May, 1956; J. DUPIN, *Miró, Quadrum*, Brussels, May, 1956; G. LIMBOUR, *Un nouveau Miró, XX Siècle*, Paris, June, 1956; H. WEISS, *Miró – magic with rocks, Art News*, New York, Summer, 1956; A. JOUFFROY, *Portrait d'un artiste: Joan Miró, Arts*, Paris, July, 1956; P. WEMBER, *Miró, l'opera grafica*, Krefeld, 1957; C. J. CELO, J. COSSOU, V. ALEIXANDRE, J. V. FOIX, F. M. LL. ANTHONY KERRIGAN, C. E. FERREIRO, L. F. VIVANCO, J. E. CIRLOT, A. CRESPO, B. BONET, J. M. CABALLERO BONALD, E. L. FERRARI, G. DE TORRE, R. GULLON, J. LL. ARTIGAS, R. S. TORROELLA, E. WESTERDAHL, F. M. LORDA ALAIZ, *Joan Miró: Los papeles de Son Armadans*, Madrid-Palma, December, 1957; E. SCHEIDEGGER, *Joan Miró: raccolta di scritti, fotografie, disegni*, Zürich, 1957; P. GUÉGUEN, *L'humour féerique de Joan Miró, XX Siècle*, Paris, January, 1957; D. ASHTON, *Miró – Artigas, Craft Horizons*, New York, February, 1957; I. YANAIHARA, *Miró's Ceramics* (Japanese text), *Mizué*, Tokyo, March, 1957; E. CLARK, *Milestones in Modern Art: Catalan Landscape (The Hunter) by Joan Miró, London Studio 154*, September, 1957; P. GUEGUEN, J. L. SERT, *L'atelier du peintre Miró à Palma de Majorque, Aujourd'hui*, Boulogne, December, 1957; J. L. SERT, *Studio for Joan Miró, Mallorca – J. L. Sert, architect, Architectural Record*, New York, January, 1958; E. RODITI, *Entretien avec Joan Miró, Arts*, New York, October, 1958; A. BRETON, *Constellations de Joan Miró, L'Œil*, Paris, December, 1958; J. BALJEU, *Mondrian or Miró, Amsterdam*, 1958; W. ERBEN, *Joan Miró*, Monaco, 1959; J. HUNTER, *Joan Miró, l'opera grafica*, Milan, 1959; J. T. SOBY, *Joan Miró*, New York, 1959; P. WEMBER, *Joan Miró, litografie a colori*, Wiesbaden, 1959; P. SCHNEIDER, *Miró, Horizon*, New York, March, 1959; W. ROBIN, *Miró in retrospect, Art International*, Zürich, 1959; H. KRAMER, *Miró retrospective at the Museum of Modern Art, Arts*, New York, May, 1959; R. MOTHERWELL, *Significance of Miró, Art News*, New York, May, 1959; J. J. SWEENEY, *Two walls by Joan Miró, Quadrum*, Brussels, 1959; M. ERNST, *Portrait de Miró, XX Siècle*, Paris, June, 1960; W. ERBEN, *Miró beim Zusammenlegen von Notizen, Du*, Zürich, October, 1960; J. DUPIN, *Vers Miró, XX Siècle*, Paris, Christmas, 1960; D. VALLIER, *Avec Miró*, (interview with the artist), *Cahiers d'Art*, Paris, 1960; J. J. SWEENEY, *Atmosfera Miró*, Barcelona, 1960; G. WEELEN, *Miró*, Paris, 1961; Y. TAILLANDIER, *Creación Miró 1961*, Barcelona, 1962; J. DUPIN, *Joan Miró*, Milan, 1963 (this volume has a complete bibliography drawn up by B. KARPEL); Y. BONNEFOY, *Miró*, Milan, 1964.